PRINTING WITH
WOOD BLOCKS, STENCILS
& ENGRAVINGS

A Victorian romantic engraving dated 1883

PRINTING WITH WOOD BLOCKS, STENCILS & ENGRAVINGS [by]

Alan & Gill Bridgewater.

David & Charles
Newton Abbot London

Arco Publishing, Inc.
New York

[c1983]

761

*Endpapers 'Carp and Cataract', a design taken from
an early eighteenth-century Japanese stencil plate*

Published in the United States by Arco Publishing, Inc.
215 Park Avenue South, New York, N.Y. 10003

Library of Congress Catalog Card Number: 82-74506
ISBN 0-668-05839-0

Published in Great Britain by David & Charles (Publishers) Limited
Brunel House Newton Abbot Devon

British Library Cataloguing in Publication Data
Bridgewater, Alan
 Printing with wood blocks, stencils and
 engravings
 1. Relief printing 2. Wood-engraving—
 Printing
 1. Title II. Bridgewater, Gill
 761 NE863

 ISBN 0-7153- 8309-4

© Alan & Gill Bridgewater 1983

Typeset by ABM Typographics Limited, Hull
Printed by
Redwood Burn Limited, Trowbridge, Wilts

Manufactured in Great Britain

CONTENTS

INTRODUCTION

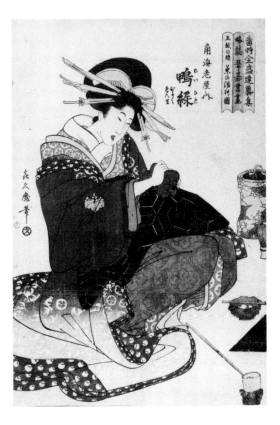

INTRODUCTION

The art of printing is defined as the act, process or practice of impressing letters, characters or figures on paper, cloth or other materials. The obvious point to note is that the transferred or pressed marks are exact mirror images of the originals. If, for example, you place the palm of your right hand into a pool of ink and then press the inked palm on to a sheet of paper, the image that you see before you looks like a picture of your left hand – a clear understanding of this fact is necessary.

My interpretation of printing with wood is broad enough to include modern materials such as wood-pulp card and prefabricated sheets, but this book is fundamentally an account of traditional relief and stencil printing processes. The essential geographical, historical and technical roots of printing are described, and the traditional wood-based craft is related to relevant projects, suitable for today.

We live in a world that takes the printed impression for granted. Everywhere around us we see evidence of printing – in shop windows, advertising, packaging, fabrics, books and newspapers; as Marshall McLuhan said, 'The medium is the message, and the message is all.' And we are now on the edge of an unprecedented technological revolution that is superseding the printed impression. Will transient television and computer images put the printed book out of business? Are we going backwards, perhaps to the time of the great monastic chained libraries, when only the privileged could look at books and feel their weight and permanence? Already schools and universities have the choice of books, computers and audiovisual aids, and more often than not the swing is away from books. Of course there is a lot to be said for photographic illustration, microchip imagery and machine-related design, but as we move further away from the actual processes of hand-manipulating paper, cloth, tools and ink, as we move further from our craft roots, so we are becoming disorientated in our approach to design. Our pattern and colour appreciation lacks social motivation.

Printing With Wood Blocks, Stencils & Engravings is more, I hope, than just a description of printing processes. It is an attempt to pull together the various printing techniques practised

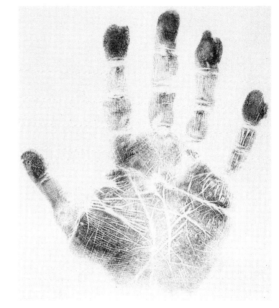

If you press your right hand into a pool of ink and then press the inked palm on to a sheet of paper, the image before you looks like a picture of your left hand. Before you can design a satisfactory print you must appreciate all the implications of this mirror-image effect

historically and ethnologically, so that when we use them today they can be related to modern thoughts and requirements. If, however, you are to appreciate the almost unlimited practical and design possibilities of printing with wood as the main block or plate medium, then it is helpful to have some knowledge of the historical and technical background.

Basically, relief printing is simply the technique of inking the proud surface of a printing block, whether wood or another material, and then pressing the inked block on to paper or textiles. Considering that the process is so simple and direct, it is surprising that it took so long to develop and for the communication and decoration possibilities to be fully appreciated. There are numerous historical practices that show some specialist use of a form of printing: for example, the Romans and the Greeks pressed metal and

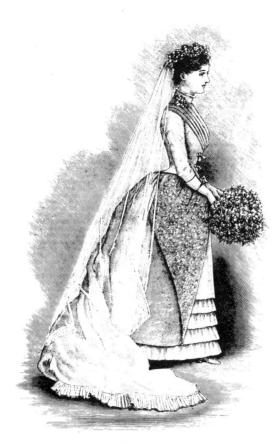

Wood-engraved fashion-plate, late nineteenth century. The marks of the engraving tools are clearly seen, especially in the white cross-hatching of the veil, the bodice and the features. Although this engraving was no doubt done in a great rush, perhaps in time to catch the press, it is in its own way a work of considerable artistic merit

wood seals into clay and wax, the Chinese and Indians pressed inked stone and wooden carvings on to paper and cloth; but apart from these religious or official marks the craft of printing as such was just not realised. Presumably the advantages of taking unlimited identical impressions were only realised when the need for mass communications and multi-production developed.

Man's ability to make meaningful marks is one of the factors that has lifted him above the other animals; even early daub cave paintings were used as educational and religious visual aids. Man has always needed concrete expressions of tribal belief and intent, and as 'man the hunter' he was satisfied with crude stone carvings, cut wooden totems and, perhaps, natural features such as trees of great age. Gradually, as small hunting groups became farming and trading communities, the

African motifs. The Ashanti tribe in Ghana and the Sudanese Bambara produce these motifs by printing cloth with a thick dye-resisting paste and then dyeing it. No registration guides are used; each motif is repeated edge to edge until the design is complete

need for record-keeping, permanent tribal histories and improved communications developed. In both East and West it was the state and religious leaders who understood the incredible potential of the printed word. After all, if a leader speaks only a few can hear his words, but if he expresses his thoughts and commands in printed words and pictures, the whole population can be influenced.

The concept of printing with wooden blocks was understood and practised by the Chinese from a very early period, and they also knew how to make flexible plant-fibre papers. However, it seems they regarded the craft as a method of working textiles and illustrative decoration rather than a means of printing text. The Eastern printers may have lacked motivation to use printing techniques for books; after all, the written Chinese language contains several thousand picture symbols, and what was the point of carving thousands of little wooden printing blocks when they had already mastered the art of speedy, beautiful, brush calligraphy. By about the second century AD the woodcut techniques of the Chinese had been adopted by the Japanese. In the first instance they saw woodblock printing as a method of producing religious tracts and charms; it wasn't until the sixteenth and seventeenth centuries that they began working the characteristic posters and book illustrations. The Japanese printers took the craft of block printing in black line and flat colour to unsurpassed heights of perfection. Maybe, technically, everything was just right – beautiful, strong, long-fibred mulberry papers and plenty of close-grained knot-free cherry wood were available, and they had a profound knowledge of wood carving, brushes, pigments and design.

Woodblock printing, as far as the West was concerned, took off in a completely different direction. When paper-making became a practical proposition in the fifteenth century, the printing of simple, almost diagrammatic, religious woodcut pictures became relatively commonplace. However, it was the invention of printing text from movable type that really inspired the use of woodcut decoration and illustration. At first the technique resulted in black-line pictures – the product of removing the ground wood of the block and printing with the high-relief wood that remained. This characteristic technique resulted in prints that were imitative of earlier, rather stylised, pen and brush works. In Germany, in the late fifteenth and early sixteenth centuries, Albrecht Dürer took the art of black-line printing to new heights of brilliance. His prints, which illustrated forms in a naturalistic,

'Girl by Lake', a Japanese woodblock print designed by Choki (also called Shiko) (1785–1805). Prints of this character were the result of one black-line printing and several colour-block printings. Although these prints were taken very much for granted in Japan, they caused a great deal of discussion in Western artistic circles when they were introduced in the eighteenth and nineteenth centuries (Victoria and Albert Museum, London)

rounded and expressive manner, set the standard for the next 200 years. In the eighteenth century Thomas Bewick, an Englishman, took the craft of relief printing with wood one stage further. Instead of cutting on the plank grain of the wood, as had been the practice, he worked on the end grain. The main difference in the two methods of working is that with end grain engraving, the lines can be finer and the depth of the cut slighter; also, the wood is removed economically with a single push of a V-shaped tool, instead of being cut with two separate strokes of a flat-bladed knife. As if this wasn't enough, Bewick also conceived the idea of working the block so that the non-printing white areas contributed to the total design structure. Working in this fashion is known as white-line work. During the Victorian period the whole craft became commercialised on a

'The Yellow Hammer', from Thomas Bewick's The Land of Birds. The vignette, a design that merges into white, is one of Bewick's favourite methods of working, and it found favour with book printers – it was much easier to make up a page of text and illustrations if the illustrations weren't surrounded by a squared-off mass of hard-edged black

A portion of a woodblock-printed lining paper – English, early seventeenth century. Some of these prints were produced by a combination of block printing and stencil printing (Victoria and Albert Museum, London)

Tailpiece motif from The Life and Writings of the Late Duke of Wharton, 1732. This sun, moon and stars framed with foliage and surmounted by either an eagle or phoenix was a common theme of the early eighteenth century – it turns up again and again in the form of wood carving, paintings, furniture swags or mounts, and book illustrations

For woodcuts (left-hand column) the wood is prepared so that the cutter can work on the side or plank grain. It is important of course that the wood has a close, even grain and is free from cavities and knots. The wood is removed with at least two strokes of a flat-bladed knife; the depth of the cut is considerable, anything up to ½in. The woodcut technique results in a print that is flat black on white; there is less emphasis on tone and 'rounded' forms. For wood engraving (right-hand column), as the actual engraving is done on the end grain of the wood, the tree logs are cut across the grain into slices about 1in thick. The most suitable woods are box, pear and holly. The wood is lightly scratched rather than being deeply cut. The brittle end-grain wood lifts as chips, and one thrust of the tool is sufficient to make the cut. With wood engraving there is considerable emphasis on the marks the tools make. The technique is a process of removing white from black, the white taking its form from the shape of the cutting tool

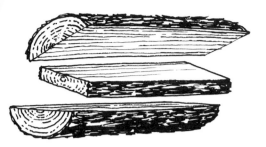 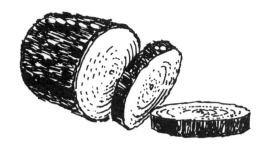

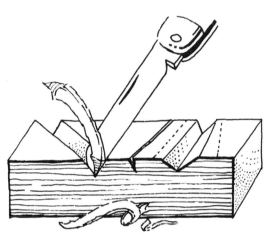

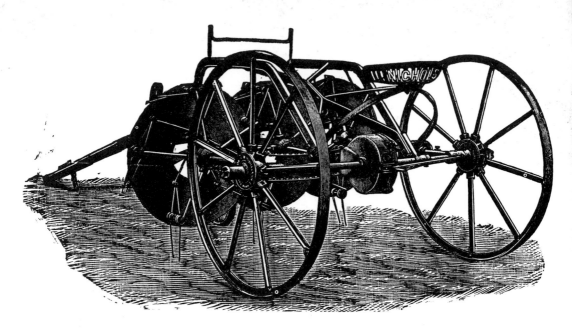

large scale, but after about 1880 there was a craft revival and artists began working with wood engraved blocks and printing in a manner that related more to pre-eighteenth-century woodcut black-line traditions.

Of course, it must not be supposed that printing with wood was restricted to the printed word and book illustration – along the way it branched out in many directions. Indian and Chinese printers developed the techniques of block printing textiles; no doubt this sprang from the availability of smooth cotton and silk fabrics. Also in the East, and later in the West, the desire of the poor for costly woven and printed hangings resulted in imitative block-printed wallpapers. By the beginning of the nineteenth century the block-printing process was expressed in three areas: book illustration, printed textiles and printed wallpapers. As far as this book is concerned, the prime mover must be William Morris; not only did he revive old and dying techniques in all areas of printing expression, but he also set the scene for all that followed in the twentieth century.

I have included various stencil-printing methods in this book because they are closely related to relief printing. Take Japanese textile

stencil printing for example: although the holes in the stencil plate are negative in the sense that card has been removed, by the time dye resists have been pressed through them on to the cloth and the cloth has been dyed, one is left with printed expressions that are positive. For similar reasons I have also included the domestic American stencil techniques of the eighteenth and nineteenth centuries. The American colonies were a conglomeration of mid-Europeans, Russians and Chinese, but somehow the separate decorative traditions of these peoples found a condensed expression in what we now think of as American wall and furniture stencil work. This craft has much in common with seventeenth-century mid-European printed and painted forms and traditional Eastern lacquer work.

It is impossible to label any of these printing techniques as specifically eighteenth-century English or whatever; all one can say is that the craft gradually developed over many centuries and in many countries. I have simplified the traditional methods and techniques in order that the craft has many exciting practical applications relating to modern needs and design modes.

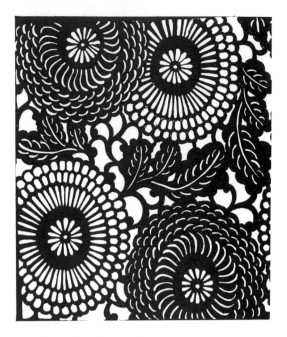

Drawing of a nineteenth-century Japanese stencil
plate, cut from handmade card

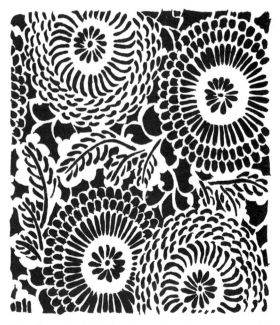

Drawing of print taken from the Japanese stencil
card shown above. Sometimes a dye resist was
printed, in which case the printed design would
match the stencil plate; in this instance, however,
the stencil plate was worked direct with an indigo
dye

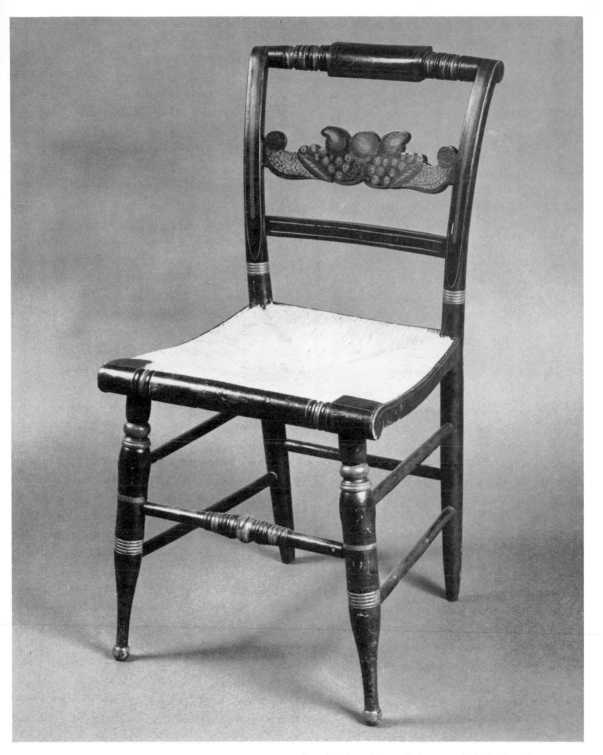

A painted and stencil-decorated chair, American, nineteenth-century. These are sometimes known as 'Hitchcock' chairs after the American furniture maker of that period (Reproduced by permission of The American Museum in Britain, Bath)

PART I
WOODBLOCK PRINTING ON PAPER

WOODBLOCK PRINTING ON PAPER

Woodcut or woodblock – both terms are used to describe the process of taking pictorial impressions or designs from hand-cut wooden blocks. A design is transferred to the plank or side grain face of a block of straight-grained wood; a knife is then used to cut round this design, and finally the ground is lowered with a gouge. When inked and pressed on to a sheet of paper, the block will leave a black-line design on a white ground. As a woodcut is worked with the intention of removing or lowering the non-printing ground and leaving the design lines that are to print in high relief, this method of working is known as black-line relief printing.

The Art and Craft of the Japanese Woodblock Print – Ukiyoe Prints

The Japanese word 'Ukiyoe' may be translated as 'floating or fleeting images', and it has been said that these prints are 'transient glimpses of an ultimate reality, as seen through a mirror'. Technically Ukiyoe are black line and colour pictorial prints on paper, produced by the woodblock method. The difficult philosophy of Ukiyoe considers that the more basic strivings of man are ludicrous and humorous but always worthy of record. The Japanese Ukiyoe artists of the eighteenth century saw the 'passing show' or the minutiae of everyman's behaviour as pattern and imagery that were meaningful and essentially self-explanatory.

Although Ukiyoe prints are now considered to be highly collectable and desirable examples of a unique Japanese art form, they originally sprang from the popular desire for 'pin-ups'. During the hundred-year period 1750–1850, the bright life of the Japanese capital, then called Yedo, with its kabuki theatres, dance groups, brothels, courtesans and stars, attracted an immense public and popular following. To satisfy the growing demand for more earthy information the publishing houses and other interested parties commissioned books, pamphlets, posters and broadsheets. The first prints were descriptive and informative black-line illustrations, but over a long period they evolved into a rather risqué means for the expression and dissemination of a naïve

A relief print taken directly from the inked surface of a piece of driftwood; the hard knots of the wood have resisted the wearing action of the sea and sand, and so stand in higher relief and consequently print darker. By studying such 'natural' prints the printer can develop a textural awareness which can at a later stage be related to his work

21

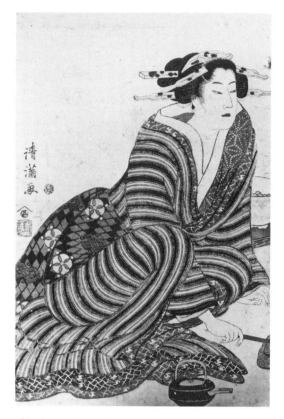

'Singing Girl' – a Japanese woodblock print of the very early nineteenth century in black and three colours. Japanese prints of this character moved nineteenth-century Western artists like Rousseau, Gauguin and Toulouse-Lautrec to reject classical European art forms. In Edouard Manet's 'Portrait of Emile Zola' (now in the Louvre) there is a Japanese print pinned to the wall (Victoria and Albert Museum, London)

bright and flat. In Japan the art of calligraphy has always had a very high standing, and consequently the Ukiyoe prints are based on smooth flowing strokes and simple calligraphic pattern forms.

In the actual production of the prints there was strict division of labour on a straight-forward commercial basis. Each of the many stages in the printing process was carried out by individual craftsmen who were only concerned with single operations. First of all the

A Japanese three-colour block print by Kitao Masanobo (1761–1816). A print of this character would have been worked by the artist, four block cutters and a printer. First a main-line block was cut and printed, and then the other related blocks were cut, one for each colour (Victoria and Albert Museum, London)

pornography. There are of course many examples of landscape prints, but I think it fair to say that the prints that we in the West think of as being Ukiyoe are characterised by coloured black-line stylisations of beautiful, flowing 'ladies of pleasure' and voluptuous, swirling and entwined lovers. The erotic but nevertheless charming innuendos of the original prints are outside the comprehension of most of us because they contain many complicated visual, language and design metaphors; however, the power, strength, shape and form of the designs are still apparent and, above all, valid.

As many of the prints were used journalistically, in the sense that they were commercial broadsheets and advertisements, it was important that the message was immediately understood; consequently the designs were hard lined and bold, and the colours used were

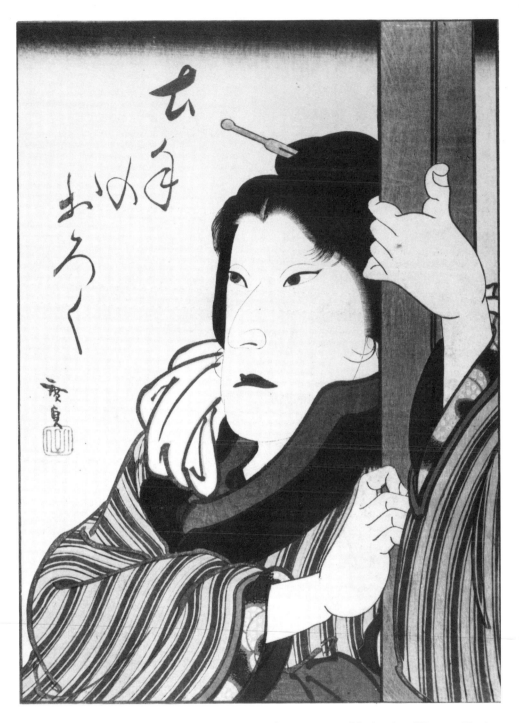

Japanese woodblock print, 'Woman Clinging to a Post', by Hirosada — early nineteenth century. The graphic qualities of Japanese prints were taken up and used by early twentieth-century American and European advertisers, and we are currently experiencing a revival in printed works that explore vast areas of flat and single hard-edged line (Victoria and Albert Museum, London)

publisher sought out and employed an artist, preferably a painter who had an established reputation. In the seventeenth and eighteenth centuries this was no easy task because the job offered little money, no prestige and was considered by the artists of the period to be hackwork. It is perhaps for this reason that many of the early prints are unsigned.

The commissioned artist would paint his designs directly on to a fine long-fibred mulberry paper, using long-haired brushes. When he was satisfied with a design it was handed over to a main-line block cutter. As the blocks had to conform precisely with the artist's main master drawing – the block cutter's task was one of precision and not interpretation – it was vital that at all stages the process and materials were consistent. To this end a tracing of the artist's master drawing was mounted directly on to the plank or sawn surface of a block of close-grained cherry wood. As the main-line master or, as it sometimes is called, key block is the most important of the series, it had to be cut with great care. It is worth noting that the block was pasted and pressed on to the working face of the design, rather than the paper being pasted and pressed on to the block; this kept paper distortion to a minimum. It was also important that the blocks were cut from single planks of well-seasoned wood – in this way the block cutters ensured that the ink take-up and the block expansion were consistent. When the mounted drawings were dry, a small amount of vegetable oil was worked into them until the paper became transparent and the black brush-work could be seen.

The actual cutting of the block involved the use of flat knives, cutters and gouges. The block was worked, cut and cleared by the cutter and

an apprentice in such a fashion that the area of the design that was to be printed stood out in bold relief. Once the cutter had finished, a proof copy was printed and shown to the artist; when he was satisfied, a number of impressions of this key block were made. The artist then coloured in the prints so that there was one for each of the various colours, and these were then handed out to various 'colour' block cutters. The colour blocks were usually intended to print large single masses of colour, so they were easier to cut and required less labour than the key blocks. As each print was composed of anything up to a dozen individual printings, it was necessary for each block to have registration marks. Registration was achieved by having, on the first main-line block, a right-angled mark on the lower right-hand corner and a straight line on the bottom edge. When proof prints were taken for the colour blocks, the corresponding registration marks were cut on each block.

Before a batch of prints were taken the firm long-fibred mulberry paper had to be prepared. The sheets were cut to size and arranged between sheets of damp paper, one damp sheet to three printing sheets, and this stack was placed to one side ready for use. The Japanese printers used Chinese black ink, coloured pigments, and rice pastes. When the ink or colour was of an even, non-flowing consistency it was brushed directly on to the block. To make a print, a sheet of the slightly dampened mulberry paper was placed on the inked block, the back of this paper was pressed with a pad or baren, and then the paper was removed. It was,

With Japanese block printing, registration is achieved by having two marks – one a right-angled cut at the bottom right-hand corner of the block, and the other a line at the bottom margin. In working, the paper is pushed against these marks, which act as stops. This approach is possible because the ink, or colour and paste, is brush-applied to selected areas

The paper to be printed is placed between dampened paper – one damp sheet, three printing papers, one damp sheet, and so on; in this way it obtains the correct moisture content. If you neglect to dampen the paper (this only applies to prints taken with water-based inks), vast quantities of ink will be sucked up and the print will be patchy

of course, vital that the paper was placed so that it fitted up against the registration marks exactly. When the prints had been overprinted with the successive colours, they were placed in a stack between absorbent cards and allowed to dry.

Project 1: Block Printing a Japanese Ukiyoe Picture

It is well worth noting at the outset of this project that of all the block-printing processes, Japanese Ukiyoe or 'floating picture' printing is the most time consuming, but not necessarily the most complicated.

Although this is a technique best achieved by wood-carvers, simple and satisfactory results can be obtained by using composition materials such as lino, plastics, acrylic film, etc, and a straightforward mechanical press. However, I would suggest that it is as well, for depth of understanding and establishment of craft confidence, to continue to use traditional woods such as cherry and box, and simple tools such as knives, gouges, brushes and pads.

The Japanese Character

I have chosen to illustrate the printing of a Japanese figure motif in the recognised style and manner, but your choice of design subject should relate more to technical ability and the required end result than to any preconceived ideas of what a print should look like. As a beginner, you will find it very difficult to control the tools, cut the blocks and make a satisfactory print, so it might be as well to work on a design that contains few colours and is relatively open, small and simple.

As for most traditional crafts, there are several design and technique conventions that are best followed: the first key-line block should be printed in black; the printed black key lines should outline the main colour masses; there should be no attempt to further describe the form by the use of light and shadow; and finally, the black lines that outline the main areas of colour should be modelled and developed so that they suggest brush-worked lines.

Designing the Print

In its simplest form the Japanese colour print is very much like a stained-glass church window in design structure – the black lines of the design describe the form, while at the same time outlining and limiting the areas of flat colour. If the master design is achieved with a brush, black ink and colour washes, the result will be fluid and delicate but also, by necessity, substantial and direct. As this master design, or a tracing of the master design, has to be pasted directly on to the surface of the block, the paper should be physically fine, semi-transparent and yet at the same time have considerable wet strength; it is for this reason that a long-fibred Japanese paper, a mulberry paper, is used. A paper of this character is ideal in that it becomes transparent when oiled and also resists stretching and distortion. (Note: All the colours and inks used on the master design must be waterproof, but all the printing inks must be water based.)

The designing of a successful colour print depends primarily on the balanced relationship between the black lines and the areas of flat colour. If the work is fussy, over-complicated and multicoloured, unsatisfactory prints will result. For the first attempt you would be well advised to limit yourself to black and two other colours. Also remember that every black brush stroke that appears on the master design must be laboriously cut around at the block stage – so do not attempt a complex 'hair-line' motif until you have achieved some mastery of the tools.

Mounting the Master Design

When the master design has been fully worked to your satisfaction and the colour relationships have been organised, it can be mounted on the block. There are several things to bear in mind. All the blocks for the one print – and in this case there will be three – should if possible be cut from the same plank of wood. If this is not practical, then the blocks should at least be equally seasoned. Cheap and badly seasoned woods take up the inks at different speeds and expand at different rates, resulting in blocks that warp and prints that are out of register. The master drawing or design has to be pasted to the face of the block, and this is best done with a wheat flour or rice flour paste. To avoid any distortion of the master design, the paste is applied to the block rather than to the design. The pasted surface of the block is pressed firmly on to the working face of the design, and then the block is turned over. The back of the pasted paper is rubbed firmly with the baren, roller or pad; great care must be taken, otherwise the paper will stretch, crease and distort.

Cutting the Block

The Japanese block cutters used simple flat knives and gouges rather than complex scoop chisels, but as these are now difficult to obtain, you could use wood-carving gouges and American chip-carving knives.

In working, the block is placed face up on a flat table; some cutters support it on a cushion and others use clamps and bench stops – the choice is yours, it really depends on your cutting method. Prior to cutting, the back of the

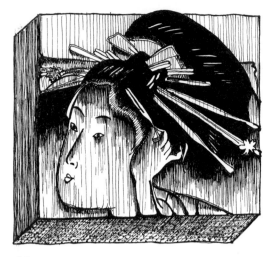

(a)

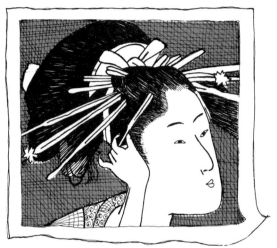

(b)

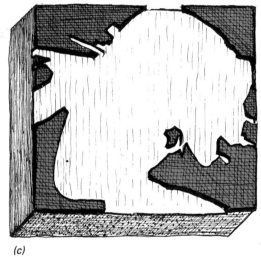

(c)

(d)

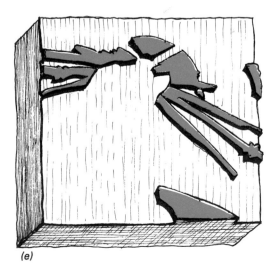

(e)

(f)

dry pasted-on design is rubbed with a light vegetable oil; this makes the paper transparent, and the black-ink brush strokes can be clearly seen. There are many ways of holding the cutting knife – some hold it like a dagger in the right hand and guide it with the fingers of the left hand, others hold and push it with the right hand and guide with the palm of the left – but the actual manner of working isn't really important, it's the results that count. The object is to cut a V-shaped trench round all the brush-work – a cut is made that follows the design but also slants away from the form. This method of working produces fine relief shapes that are strong and broad based; it also means that there is less chance of damaging areas that are to be printed. Once the cutting has been completed, all the white (non-printing) ground is cleared away with the scoop gouge.

The method of registration with the Japanese block print is very simple – a 90° angle cut at the bottom right-hand corner of the block and a line cut parallel with the bottom edge of the block.

Impressions from the Key Block

Once the main-line or key block has been cut, impressions must be taken from it – one for each colour that is to be printed and several for reference. Before the block can be inked, all remains of the pasted-on paper design must be washed off, and this can best be done with warm soapy water. When the surface of the block is clean first brush the working face with a water-based printing ink and then a flour paste; the paste gives the ink a firm shiny texture. There are now, of course, inks that can be used straight from the tube without the addition of a base medium, but because of their unpredictability they must be used with caution. Once ink has been applied to the block, impressions are made on thin Japanese paper –

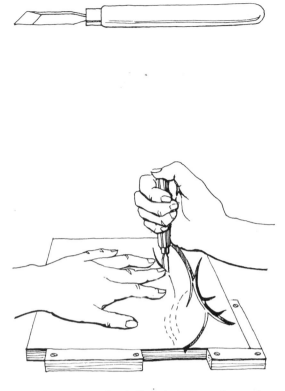

The Japanese cutting knife is held like a dagger in the right hand and guided with the fingers of the left hand. It is helpful if the block that is being worked is supported against bench stops

Printing method:
(a) With the first main-line or key block, wood is cut away until only the relief area that is to print black remains
(b) Several prints are taken from the key block – one for each colour that is to be printed and several for reference. These prints are coloured up and pasted on to the working face of the various colour blocks
(c) With this first colour block, wood is removed so that only the background area of the block will print
(d) This illustration shows a print of the key block which has been overprinted with the first colour block
(e) A block is made for each separate colour printing – in this instance only a few areas are left in high relief
(f) Finally, the key print is overprinted with the other colours. Obviously it is most important that all three blocks register correctly

make sure that these are correctly registered and that the key lines are clear. Each of these key prints is in turn paste mounted on a block and, as already described, cut and worked. For our two-colour and key-line print, three blocks will be needed.

Preparing the Paper

There are many types of paper that you could use, but a good printing paper tends to have these characteristics: it is slightly absorbent, it is long fibred and so will stand up to damping and considerable handling, and it is pleasing to the eye. If the paper is too absorbent it can be brushed with a thin vegetable size and then left to dry. When the correct paper has been obtained and cut, it must be dampened before printing can proceed. The traditional way of doing this is to place three sheets of printing paper between two sheets of damp paper. In this way a stack of printing paper is prepared – one damp sheet, three dry, another damp sheet, three dry, and so on.

Printing the Key Block

The printing table should have a smooth

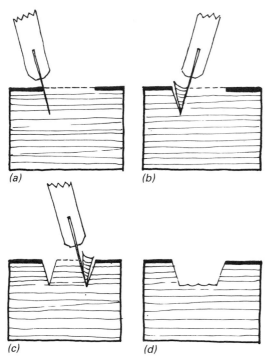

(a)

(b)

(c)

(d)

Cutting the block:
(a) cut at an angle away from the area that is to remain in high relief; (b) remove a V-shaped trench that follows the main lines of the design; (c) continue removing V-shaped trenches round all printing areas; (d) finally clear out all the waste non-printing ground

surface which is easy to clean and maintain – a kitchen table of average height is perfect. The layout of the equipment is simple: the block to be printed is placed on a pad of damp paper to prevent it sliding about; the printing paper is placed in a stack which is close to hand; and the inks, a bowl of paste, several brushes, a sponge and the baren, pad or roller are all placed within easy reach.

All prints, impressions or pulls, whether black line or colour, must be done smoothly, swiftly and rhythmically – in this way mistakes and bad registration can be avoided. The printing method is as follows. The block is wiped with a clean damp sponge, ink and paste are brushed on to it, then a piece of damp printing paper is lifted from the stack and placed on the inked block. The placing of the paper is critical; it must be placed in the registration marks, but at the same time it must not be dragged around over the inked block – be ready for quite a few mistakes. When the paper is in place, the baren or roller is moved backwards and forwards and from side to side over the entire surface. If too much

Arrangement of printing table:
(a) dampened paper stack; (b) key print on damp paper; (c) bowl of paste, ready to brush onto block; (d) printing block resting on a pad of damp paper (this prevents it sliding about); (e) baren or burnisher; (f) sponge for cleaning and moistening the block; (g) bowls of ink or colour; (h) brushes

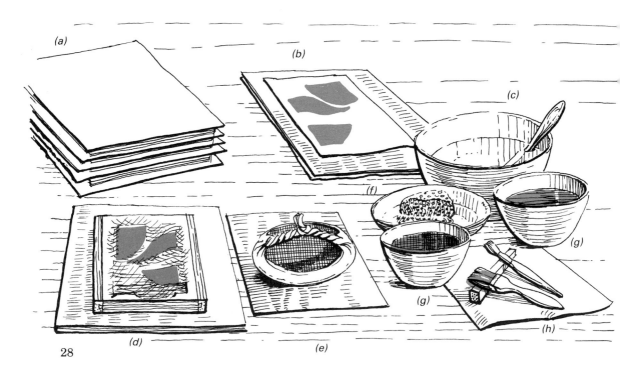

pressure is applied the sharp edges of the block will cut through the paper, if the ink is too thin it will splodge about and make a mess. A good pull or impression will be consistent in colour and clear in definition. As the prints are taken they should be placed in a stack on damp paper; if the ink is of the correct consistency, they can be stacked directly together without fear of damage or offsetting.

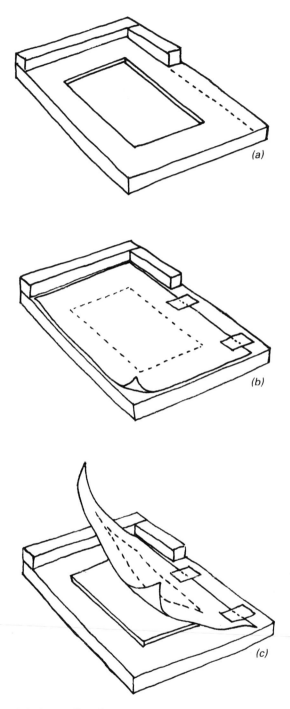

(a)

(b)

(c)

Printing the Colour Block

To ensure good registration, printing of the colours must follow the main-line or key-line printing immediately – if possible while the paper is still damp. The colour blocks are printed in much the same way as the key block, but there are one or two important differences. The layout of the work table is unchanged. As a general rule, the paper must be kept damp and more pressure must be applied to the baren, but this will vary with paper types and colour consistency. As printing is, by its very nature, a craft process of continual trial and error, a great deal of personal experimentation is inevitable.

The method is as before – the block is wiped with a clean damp sponge, colour and paste are applied with a flat wide brush, and the damp paper is taken from the stack (this time of course it will be already printed with the key line) and placed face down on the block. Great care must be taken that registration is correct; once you are satisfied, the back of the paper can be firmly rubbed with the baren or roller. Finally, the print is lifted and placed to one side.

If the completed prints are left to dry in a stack they might develop a mildew, and if they are left to dry singly they cockle. They are best dried between boards of absorbent card.

Hints

The main problem is getting the correct overprinting or registration, and it is vital that the moisture content of the paper between printing stages is constant. If the paper is allowed to dry and so shrink or get too wet and expand, the overprinted colours will not fit. With relief block printing, the registration can never be more than approximate, but it is, after all, the prints that are very slightly out of alignment and the unavoidable differences of ink and colour densities that go towards creating the exciting, characteristic, visual and tactile textures. The depth of the colour, the amount and consistency of the inks, the type of paper to use and registration control are all matters of skill and judgement that will come with experience and experimentation.

Printing registration:
(a) a recessed wooden baseplate that will take the printing block is made – registration is achieved by having two battens along the top and side edges; (b) the paper to be printed is fixed with masking tape so that in working it can be opened and closed like a book; (c) the printing block is placed in the recess, inked, and then the print is taken. For subsequent colour printings the same procedure is followed

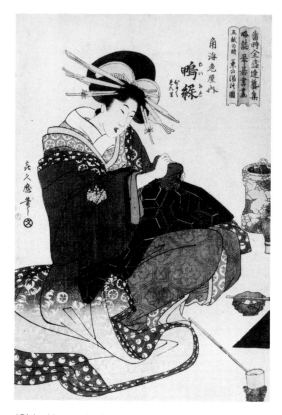

'Girl taking tea' – Japanese, 1886, three-colour block print, tinted and brush-worked. A most beautifully worked print – note the overprinted pattern on the skirts of the kimono (Victoria and Albert Museum, London)

Printing with Woodblocks or Woodcuts in the European Manner

It is believed that the art of printing with wooden blocks first developed in China, India and Japan. The blocks were used in much the same way as seals or stamps – a pattern was cut into the wood, and an impression was then made by pushing the block into clay or on to damp paper. Although there is further evidence suggesting that simple prints were made in many parts of the world, the technique remained more or less static for centuries. Around 800 AD in Egypt, India and China, coloured stamps were used to impress and print religious motifs on scrolls and texts, but these were only used on a very limited scale. There are European examples of blocks being used to print basic textile patterns as early as the sixth and seventh centuries AD, but generally speaking the technique of using carved wooden blocks to print on paper didn't appear in Europe until the late fourteenth century. It seems highly probable that the consequent growth of

woodcut printing was linked to the development of large-scale paper-making methods.

At first the craft was limited to the printing of devotional images, religious and educational pictures, and playing cards. The initial woodcut technique was restricted to the printing of thick, crude black lines, which were more often than not daubed with colour. As the colour is splodged over the printed lines in most examples, it seems likely that the first prints were just 'fill ins' or guides for the colour artist. The technique was used simply as a means of 'getting the message across' to large numbers of people; there was no attempt at any finish that could be described as artistic or refined. It is apparent that these early prints were not intended to be creative, in the sense of being works of art – they were transient, mass-produced pictures that could be bought cheaply.

By about the middle of the fifteenth century, blocks were being cut that had words as well as pictures, but as the letters of each word had to be cut in mirror image, the text was usually short. When printed in editions, these early works were often collected, pasted back to back and then sewn together – we know them as block books. At this period, the technique of woodcut was still restricted to the printing of

Woodcut, 1485, Aesop's Fables – Libistici Fabulatoris Esopi Vita Naples. An early print in the black-line diagrammatic style; the black areas represent the relief parts of the block (Victoria and Albert Museum, London)

thick black lines that described the image, leaving pools of unprinted white which could be quickly filled in with colour. Making the block was hard, slow work because it had to be cleared of all the ground except the lines that were to print, and these were left in high relief. The method was, in essence, a way of imitating the pen or brush line.

The invention of movable type in Mainz in the middle of the fifteenth century meant that the subject matter was no longer restricted to simple religious and communication handouts. At the same time, the demand for woodcuts was growing with an increased desire for education. The designers gradually became more adventurous and left larger areas of uncut wood, or surfaces that printed black; these further helped to describe the form and added another dimension to the print. But the most dramatic development in woodcut technique was effected by one man – Albrecht Dürer.

Born in Nuremberg in 1471, Dürer lifted the rough craft of making woodcuts out of the Middle Ages and transformed it into an expressive and individual art form. (Later in this chapter there is more about his life, but for the moment we will discuss his woodcut techniques.) With his restless genius, Dürer insisted on working in fine detail, his sole aim being to create images that were naturalistic and three-dimensional. He designed the blocks in such a way that the prints were composed of black printed lines on a white ground and thin cut lines surrounded by black. At their best, these prints were like fine pen drawings. It isn't likely that Dürer cut his own blocks – up to the end of the nineteenth century it was the custom for an artist to design the work and a craftsman to make the block – but his beautifully conceived designs would have made stimulating demands upon the cutter. Dürer's works were well known in his own lifetime, and it is on record that they made a great impact on other designers. They were printed and sold in large editions and their unprecedented influence was felt all over the civilised world.

By the late fifteenth century, the process of printing with woodcuts was common enough, but it was still more or less limited to black-line prints. It must be understood that the object of the printers of this early period was to produce work that as far as possible imitated drawings and paintings. Many designers were trying to produce work that could be printed in several

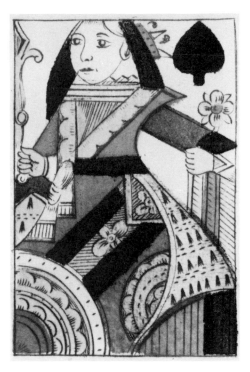

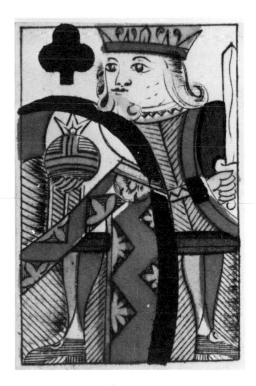

English playing cards (1789–1801), King of Clubs and Queen of Spades, block printed, stencil worked and painted. The lines of the block print are just guidelines for the colourist (Victoria and Albert Museum, London)

31

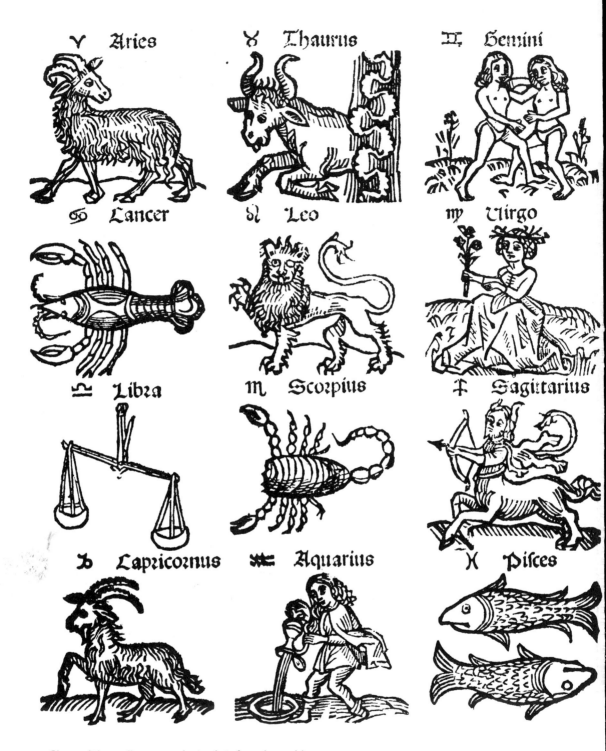

Signs of the zodiac – woodcut prints from Leopold of Austria's De Astrorum Scientia, *Augsburg, E. Ratdolt, 1489* (Victoria and Albert Museum, London)

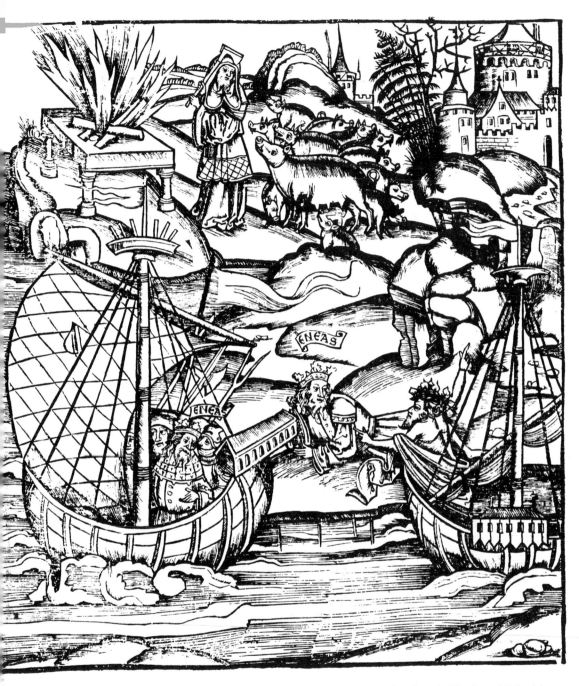

A woodcut from Gruninger's Virgil, *published in Strasburg in 1515 – 'The god of the Tiber appearing to Aeneas', from Book VIII of the* Aeneid. *The technique of cutting the block, as illustrated by the print, began to explore tone, depth, and form; no longer were the illustrations limited to diagrammatic black line (Victoria and Albert Museum, London)*

Drawing of the letter 'D' from the Opera *of Vespasiano Amphiareo, 1545. A woodcut that relates to the earlier pen-worked manuscripts*

Woodcut from The True Briton, *1723. Tailpieces of this character were worked in miniature (this print is actual size)*

Woodcut from The True Briton, *1723 (actual size). This particular print appears several times in the book, but with different centre motifs*

colours, others were trying to produce prints that were composed of several tonal changes. The result of all this effort and experimentation was that in the early sixteenth century Hans Baldung Grien was working in Nuremberg on colour block printing, Ugo da Carpi in Venice was printing in tones or chiaroscuro, and Hans Holbein was working on detailed and intricate cuts. Of course, these three were not working in isolation – there were many other innovative designers and cutters working in Holland, Germany, England and Italy – but I have only mentioned artists whose work can easily be seen, dated and identified. As far as woodcuts were concerned, the seventeenth, eighteenth and early nineteenth centuries were a poor time: the technique had, in the eyes of the trade printers, been superseded by wood and copperplate engraving. This is not to say that the craft of woodcut was of less value creatively, but more that it had to give way to techniques of printing that were more commercially acceptable.

At the beginning of the twentieth century there was a revival of interest in woodcuts and wood engraving; in the hands of artists they became a medium that was strong and capable of great expression. The customary method of working – an artist designing the block and a craftsman actually cutting and working it – had led, over a long period of time, to a distancing between the conception of the design and the reception of the block. This gap between artist and cutter had continued to widen until, by the end of the nineteenth century, block cutters were considered to be artistic nonentities, mere mechanics. Now artists not only conceived the designs, they cut the wood and printed the blocks, so that the work produced was direct and individualistic. The principle was the same, the relief surface still carried the ink, but this time there were no hard and fast rules of method and technique. Artists such as Gauguin, Beckman, and Munch used the craft as a form of personal artistic expression. Blocks were cut, rough sawn, scarred, scratched and incised with all manner of tools. Prints became textural impressions rather than representational expressions.

Albrecht Dürer

Albrecht Dürer, born in the year 1471, was the son of a Transylvanian goldsmith. When Dürer's father settled in the German village of Eytas or Dür, meaning 'door', and set up his workshop, he took the name of the village for his own. It is on record that Dürer's father was a good goldsmith but always in a bad way financially – perhaps eighteen children (Albrecht

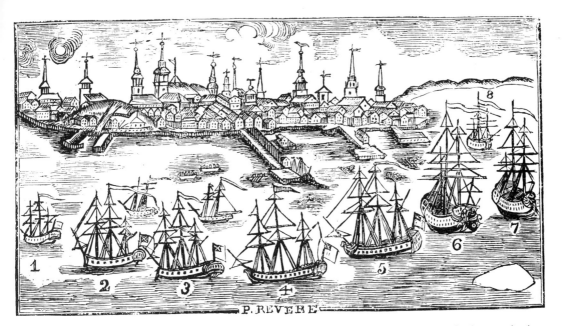

There is often confusion as to whether a print has been taken from a woodblock or a metal plate. This particular print, which shows the landing of British troops at Boston, in 1768, was engraved on copper (not a relief-printing process) by Paul Revere, one of the earliest American engravers; it appeared in Edes and Gills's North American Almanack and Massachusetts Register for 1770. Note how the lines of the print have a 'drawn quality' and in places they even overlap — this is what distinguishes it from a block print

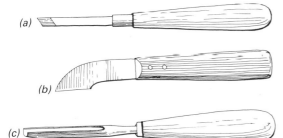

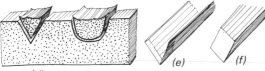

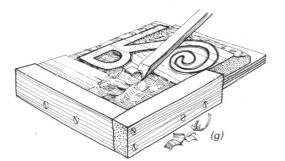

Cutting tools:
(a) Woodblock cutting tool with a sliding ferrule — the length of the blade can be adjusted
(b) Curved-blade European knife
(c) For lowering large areas of block ground, a U-shaped gouge can be used
(d) Obviously the shape of the cutting tool will decide the shape of the cut. Great care must be taken so that relief areas that are to print are not undercut and weakened
(e) Simple V-shaped gouge
(f) Flat chisel, which can be used for shallow ground work
(g) In working, the block must be supported against bench stops to prevent it moving. Note: always cut away from the design

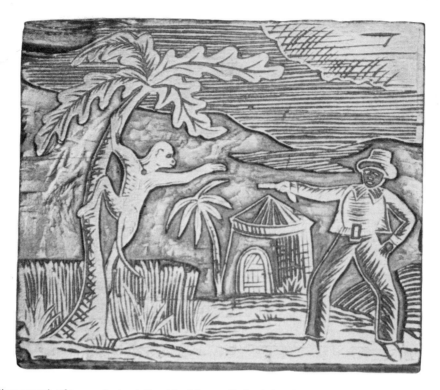

(above) *Photograph of a woodcut printing block by an unknown artist, probably eighteenth century. The surface of the block has acquired a metallic-like sheen in use* (Millgate Museum of Folklife, Newark on Trent)

(below) *A print taken from the block shown above. The fine crack which goes across the surface of the block appears on the print as a white line cutting through the reeds (just below the monkey's tail)* (Millgate Museum of Folklife, Newark on Trent)

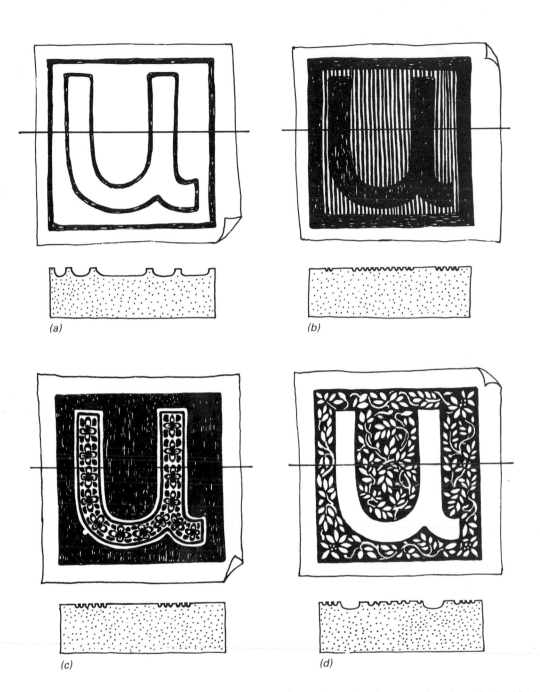

Four prints, showing a section through the block corresponding to a line marked on the print:

(a) The simplest cut – the bulk of the ground wood has been removed, leaving only a thin ridge which prints as a black line

(b) With this print the background to the letter 'U' has been furrowed, and the actual 'U' left as uncut block, so the letter prints as positive or black

(c) In this instance the ground round the 'U' has been left uncut, and it is the letter that has been worked

(d) The letter 'U' has been grounded out of the block, and the surrounding area has been pattern carved

37

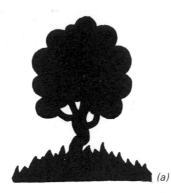
(a)

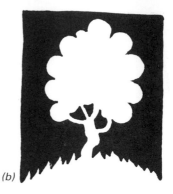
(b)

(c)

(d)

(e)

(f)

Design techniques:
(a) Silhouette black – the ground of the block is cut away so that only the tree prints
(b) Silhouette white – the subject is lowered so that the ground area around it prints
(c) Outline black – the ground area of the block is lowered to leave the subject (tree) described as a black line

(d) Outline white – the tree is worked on the block as a thin cut line, it prints as black ground
(e) Half-tone – the ground of the block and selected areas of the tree are removed; the effect when printed is that of light, shade and form
(f) Shadow and counterchange – the block is worked so that there is a balance between black and white

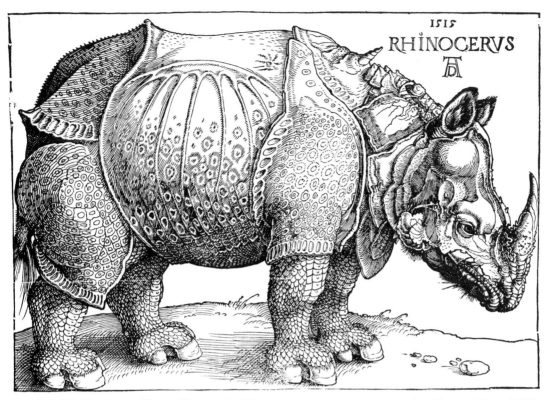

1515

RHINOCERVS

'Rhinoceros' – woodcut by Albrecht Dürer (1471–1528). A work of art and a technical masterpiece. Note the belly of the animal – if all the white areas on this print represent block wood that has been removed, then what appears to be drawn cross-hatched black line is in fact an area where the surface of the block has been systematically nicked and lowered (Victoria and Albert Museum, London)

was the third) and an ailing wife were just too much of a burden. The financial insecurity of the father may have transferred itself to Dürer, for it is obvious from his diaries that he desperately sought social, monetary and artistic recognition. He started to train as a goldsmith but was soon neglecting his work in favour of painting and drawing. When his father realised that his son's talents were exceptional, he apprenticed him to Nuremberg's top painter and printer of the period, Michael Wolgemut.

It is known that there were at least a hundred apprentices and twenty presses in Michael Wolgemut's printing workshop. With this creative stimulation and the wonderful facilities, it must be supposed that Dürer's talents as a woodblock cutter and designer rapidly emerged. He finished his apprenticeship in 1490 and became a journeyman assistant – a sort of casual labourer who worked for printmasters. There are several gaps in our knowledge of his next move, but it is thought that he worked in Colmar in Alsace, Strasbourg and Basle. From the known work it can be seen that he developed a style of work, composition and line that set him apart from other artists of the period.

In 1494 Dürer's father called him back to Nuremberg and married him off to a girl called Agnes. If her portrait is anything to go by, Agnes was not much of a romantic, but she did

have a good head for business. This is borne out by Dürer's diaries – he mentions her only in connection with business accounts, orders, commissions and sales. We don't really know much about Dürer's home life, but after a few months of marriage he decided that an artistic fact-finding trip to Venice was vital if his education was to be complete. Although it can be seen that Dürer's work of this period was influenced by his admiration of Italian style and techniques, it is also obvious that his compositions and methods of working were entirely his own. By the time he had returned to Nuremberg, his wife and the printing business, he was a bit short of money and turned to the money-making craft of copper engraving. This printing technique, unlike the relief-printing process of woodcut and wood engraving, is one where the actual cut line of the plate carries the ink and is therefore identical to the printed line.

Over an extended period of about seven or

eight years Dürer gradually returned to the woodcut method of working. Round about the year 1500, the population of Europe was going through a spiritual, intellectual and religious upheaval. It was a popular belief that the world was going to come, almost immediately, to an explosive and violent end. Inspired by the themes of death, retribution, torture and eternal damnation, Dürer designed and printed the fifteen woodcuts that we know as the *Apocalypse*. He captured the mood and vision of the period so perfectly that there was a universal clamouring for his work, and being a good businessman, he swiftly produced another series – this time based on the theme of the passion of Christ. Never again did his work reach such a height of popular acclaim, but as an artist of some brilliance he was well and truly launched.

Albrecht Dürer was an amazingly complex character, one who was without doubt an artistic genius. He was driven by the almost overwhelming desire to master all the forms of artistic representation. By about the age of thirty he was recognised as being a great portrait painter, a brilliant copper-plate engraver and a superb woodcut designer. From his middle thirties, Dürer gradually became obsessed with the notion that human perfection was somehow linked with geometry and mathematics. He struggled to draw the human body so that it conformed to certain rigid theoretical values – of course we now realise that his task was not possible because his original concepts were based on a false premise.

As Dürer developed and became confident in his own artistic ability, he started signing his work with the familiar Dür or Door symbol. In 1504, when he had reached a peak of public acclaim and was visiting Venice – then the art capital of the world – he was everywhere recognised for his genius. As an artist he began to focus his attention more and more on painting altar pieces, and during the years that followed his visit to Venice, he received a great number of commissions to paint both these and portraits. Although Dürer had now achieved his aim of being financially secure, he was so busy that his artistic development came to a halt while he worked and reworked old themes. This is not to say that he was mass-producing without thought to quality, but he was certainly working to order in the sense that he was required to have paintings of a given size and theme finished on time.

Over the next twenty years, until his death in 1528, Dürer worked on many copper engravings and paintings but few woodcuts. During the last eight years of his life he

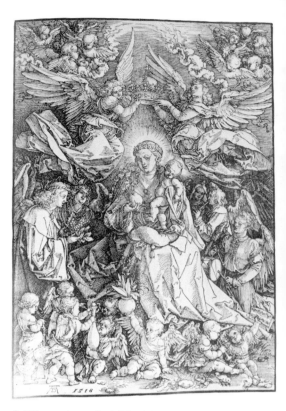

A Dürer print called 'The Virgin Crowned by Two Angels', dated 1518

retreated into a world that was contemplative and intellectual as he tried to explain and prove his theories of human aesthetics and proportions. At this time there was a great deal of religious and social unrest, all of which he worked through apparently unaffected. Maybe Dürer was conscious of the dangers of involvement, or maybe he had reached a time when he was tired and totally involved in his own work and thoughts.

Dürer's work has often been criticised and described as being brutal and obsessively violent. This of course cannot be denied; he was a child of his times and brutality and destruction were the order of the day. Albrecht Dürer was, however, a designer of considerable genius, and it can never be disputed that he took the art of woodcut to amazing peaks of technical achievement – no longer were woodcuts considered as a clumsy means of simple print reproduction.

Hans Holbein

Hans Holbein the younger was born in Augsburg in 1497, at a time when his father

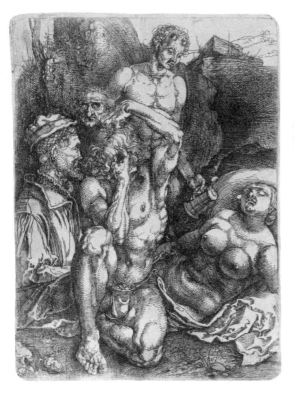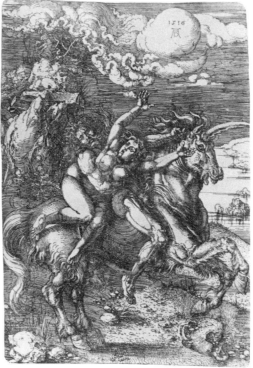

For a short period Dürer experimented with metal-plate etching, as you can see from the two photo-graphs. It is a technique of drawing lines rather than leaving them in relief

was already a popular and successful painter. In a way, the whole of his childhood can be considered an apprenticeship, for he must have spent a great deal of time watching his father at work. When Holbein was about sixteen, he and his brother left Augsburg and set up a home and studio in Basle – at that period Basle was one of the most important publishing towns in Europe, so it was the obvious place to go if you were at all interested in printing. When still only sixteen, he illustrated the title page for Thomas More's prestigious work *Utopia,* and although he was by this time an accomplished designer, it was this single cut that established his international reputation.

During the years 1520–1528 Holbein's fame as a painter and designer spread right across Switzerland, Germany and England. At this period the whole of Europe was in a state of political upheaval and religious unrest, and it was against this background that Holbein attempted to work. Life became really difficult when religious reformers declared that 'representational paintings were idolatrous'. We don't know whether Holbein was actively involved in the 'for' or 'against' argument, but it is certain that he found the whole atmosphere of religious repression restrictive. He decided that he wanted to work in a more tolerant

environment, so at the age of about twenty-eight he went to England with an introduction to Thomas More and once again set up home and workshop. At that time, Thomas More was still on good terms with the king, and the king was still on good terms with Rome. Holbein was commissioned by More to paint a family portrait so he must have made a good impression. By 1532 he had settled down and was working well, his reputation in England firmly established. The period 1532–1535 was difficult for Holbein; he was aware of the enmity that had broken out between Henry VIII and Thomas More and yet he somehow managed to keep on friendly terms with them both. Of course all this political wheeling and dealing meant that he had to tread very carefully. He must have been something of a politician, because by 1536 he had become the king's painter despite the fact that More, his friend, had been executed for treason.

Over the next seven or eight years, until his death in 1543, Holbein produced a great number of works, but unfortunately few

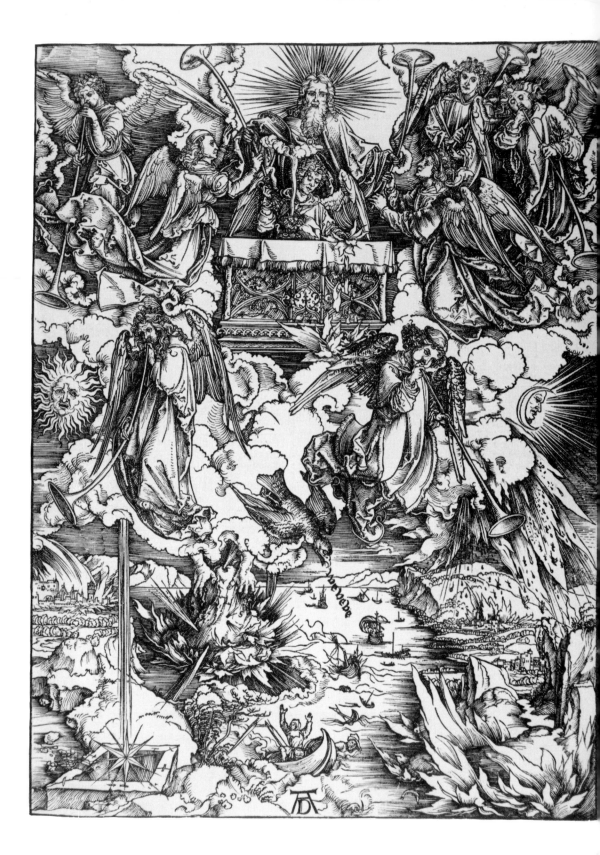

'Adam and Eve' – by Hans Holbein the Younger, for the Historiarum Veteris Testamenti Icones (Old Testament) published between 1538 and 1549. Although there is a fair amount of tone, this particular print is in the black-line tradition

Woodcut by Hans Holbein the Younger for the Historiarum Veteris Testamenti Icones. The motifs used in this print occur in many of Holbein's works; the treatment is confident, direct and well considered

Dürer woodcut, 'Seven Angels with Trumpets'. This print appeared in the Apocalypse, in 1498, and is perhaps one of the finest of Dürer's cuts. It has been said that Dürer was 'overwhelmed by his own powers of artistic expression' (Victoria and Albert Museum, London)

remain from those that survived. It is obvious that he delighted in intricate detail and finely worked ornamentation, and it is this, so far as woodcuts are concerned, that makes his work special. Woodcut is an art that calls for an economical use of line and clarity of form; there quite literally isn't any room for ill-considered design work. Many of Holbein's religious themes are rather ambiguous, but as he often worked in an atmosphere of political extremism, this isn't surprising. He probably concentrated on secular portraits because he was working against a background of Henry VIII's marriages and repeated religious and political turnabouts – he did after all have to make a living and stay alive.

Holbein's importance as a woodcut designer lay in his ability to produce well-organised illustrations. Between 1522 and 1530 he created his brilliant works *The Dance of Death*, and a series for an illustrated Old Testament. With both Holbein and Dürer, there has always been some doubt as to who should have the credit for the work, the cut designer or the actual cutter. Of course, it is possible that they worked on their own blocks, but that has to remain a matter for conjecture. Suffice it to say that Holbein's designs are considered to be forceful, precise and beautifully composed.

Project 2: Block Printing a Poster

How many times have you been asked to make a great number of posters for the church jumble sale, the school play or the club? Let us say, for example, that you have been asked to produce at least ten posters that give all the necessary information – date, time, etc – in an attractive and colourful manner. No doubt it would be possible to draw out each poster with pen and ink and then colour the letters individually, but this would be time consuming and, by the time you had reached the tenth poster, the whole task would have become wearisome. This particular project describes a simple way of producing a considerable number of identical prints at little effort and cost. Only large bold shapes are practical, but at least the process isn't tedious or expensive.

I have chosen to print a large three-colour poster that gives all the information for a club event. The poster is in essence a medium of instant communication, and to this end it must have a large instantly recognisable motif – one which encapsulates the club's aims and ideals. Once the poster has 'caught the eye', it then has to relay a message – precise details of event, date, time, etc. I am assuming that the basic printing block, with the motif and the name of the club, is to be used again and again; this

43

A print taken from an early nineteenth-century woodblock letter. Note the white blurs – these are caused by using a dirty roller and by inadequate burnishing

Idea for the poster project – by careful cutting, all the cut-out shapes from one piece of ply can be used. In this instance the black motifs underneath the word 'craft' relate to the white cut arches above the word

being so, a space will have to be set aside so that these specific details can be written in by hand.

The character and design of this poster relate directly to the size of the block, the cost of materials and the premise that the printer will have little or no experience.

Choosing the materials
As we are going to print a large number of low-cost posters, it is perhaps a good idea to use materials that are predictable, uniform and easily obtainable. I have chosen ¼in marine or exterior plywood for the block base and letters, and plain white absorbent card for the poster. As it is more than likely that the poster will have to face up to damp and maybe even rain, I have used acrylic paints for the printing medium. The advantage of using a paint of this type is that it is water based and so it can easily be washed off the equipment, but when it is dry it is waterproof.

Preparing the Printing Table
As this project is designed for someone who wants a quick functional poster, rather than for a person who is already a keen printer, it is necessary that a temporary printing table be organised with the minimum of construction and fuss. Almost any flat surface is adequate, but it is important that there is an immediate source of water for washing down, paint mixing, etc. With this in mind, it might be as

(left) *Sketches for the poster project. If possible use motifs which further describe the poster theme – football, flowers, etc*

(right) *Making the block:*
(a) When the letters, etc, are being cut from the plywood, it is helpful if the ply is clamped firmly to a bench or table
(b) When you are arranging the design, give it some considerable thought. Don't be tempted to make do with a small piece of card – remember the advertisers' motto, 'space speaks'
(c) When the cut-out forms have been satisfactorily arranged, glue is applied
(d) Once the glue has been applied, the base board is positioned
(e) When the glue is dry, the relief forms should all appear in reverse – if you want to check on the placing, hold the block up to a mirror
(f) Registration strips are pinned to the side of the base board, making sure that in total depth they are slightly thicker than base board plus relief forms

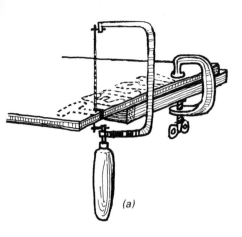

(a)

(b)

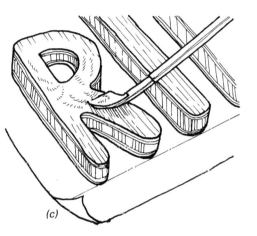

(c)

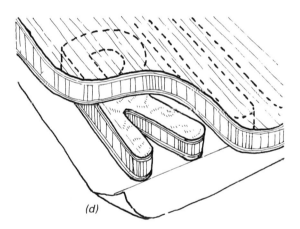

(d)

(e)

(f)

well to set up the printing workshop in the kitchen and use the kitchen table for the printing – a plastic-coated work surface would be ideal.

Preparing the Blocks
As the plywood has to be cut, pierced and worked, you will need a steady work surface – a bench or table will do – and a fine coping or fret-type saw. The method of working is very simple and direct. The letters and the motif have to be designed so that they contain as few acute angles as possible. The object of the exercise is to try and ensure that the main lines of the letter and motif forms are curved and flowing; this will facilitate easy cutting of the plywood and minimise the problems of poster structure and design. Once you have decided on the poster content and the size, style and relationships of the forms, a master design must be drawn up. If you are really trying to cut costs, all the design and pre-design work can be carried out on sheets of newspaper. When the letters, etc, have been worked and considered and then drawn on the newspaper, they can be cut out and placed on the plywood. At this stage the forms can be juggled around until they are arranged in a way that is most economical; letters and motif are then mounted on the wood with a wallpaper paste.

In working, the wood has to be fretted so that the cut edge is at 90° to the printing surface; this isn't critical but a well-cut sharp edge gives a good sharp printing definition. If any of the sawn edges are ragged, they must be rubbed with sandpaper, but try not to round them. Cut a piece of newspaper so that it is the same size as the poster and arrange the cut-out forms so that they are as envisaged and designed; even at this late stage there is room for reshaping. (Note: the letters should be arranged face up so that they read.) When you are satisfied with the composition of the poster, brush a small amount of PVA glue on to the forms, and with great care lower the base board into position. If you are sure nothing has moved, weigh the board down with a couple of bricks or a pile of books. When the glue is dry, turn the base board over and clean up.

Registration Marks
As the now finished block is as large as the poster, it will be easier if in working it is placed face up on the table. You will see that the letters, etc, are in reverse or mirror image; this is as it should be. Registration is achieved by pinning three ¾in strips of wood to the sides and bottom edge of the block. As the height of these strips is greater than the total thickness of the base board, the glued-on shapes and the printing paper, they will act as adequate stops for the paper during printing.

Printing and Working Method
In most aspects this project is similar to the one on Japanese block printing, the differences being scale, materials and tools rather than technique. With all printing methods it is important that the work is done smoothly, swiftly and rhythmically, and to this end a lot of thought must be given to the arrangement of the equipment and materials. The printing card or paper is damped in the Japanese fashion – three dry sheets between single damp sheets. The stack of printing paper is placed close at hand. The block is placed face up on a wad of damp newspaper to make sure that it doesn't skid about. The acrylic colours are mixed to a stiff non-flowing consistency and placed in saucers, one brush and one saucer for each colour. A sponge and water and a smooth bone or spoon burnisher are also placed close at hand.

The printing method is as follows. Wipe the printing face of the block with the damp sponge, swiftly brush the colours on to the letters and motif, place the printing card or paper on the block and then burnish. As the act of burnishing is the culmination of the printing process, it is vital that it is done with care. The paper is burnished until the block can be felt and the work assessed. The thumb is pressed into the dish of the spoon which is then rubbed across the surface of the paper. When the lines of the block appear as shiny hard-edged plateaus then the burnishing is complete and the paper can be peeled off. I have printed all the colours in one pull or impression because my forms are generously spaced, but if your letters are close together the colours must be printed separately – the accurate method of registration allows for this. I have also applied the colours to the block with a brush; this is a personal preference, and you may find that a roller will result in a more consistent colour coverage. The wet prints can be placed on one side until dry.

Hints and Tips
There are a great number of cards and papers on the market, all of completely different textures and absorbencies, so it is wise to shop around and get samples. If possible, buy the card direct from a printer. The amount and consistency of the colour applied to the block is critical – it must be used sparingly. As acrylic colours dry fairly rapidly it is wise to mix only small amounts at any one time. The brushes and the block must be washed at frequent intervals.

PART II
WOODBLOCK TEXTILE PRINTING

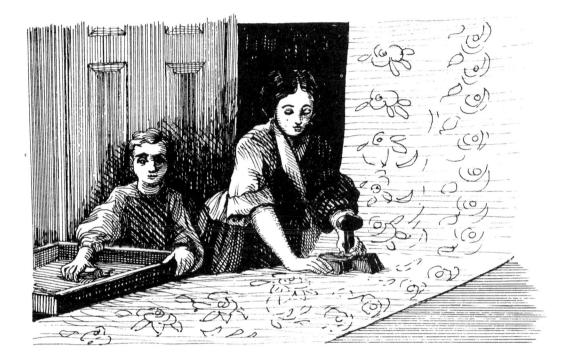

WOODBLOCK TEXTILE PRINTING

In nearly all technical essentials woodblock printing on textiles, let us say cotton or silk, is identical to woodblock printing on paper. The plank grain face of the wooden block is worked with knives and gouges until the area of the design that is to carry the dye or colour stands clear in high relief. The material that is to be printed is spread and fixed on to a flat resilient surface; the working face of the block is pressed on to a dye pad; the block is then placed on the surface of the cloth so that it relates to certain grid marks; and finally, the block is struck and then removed. If a length of cloth is worked systematically in this manner, a printed fabric of a predetermined design will result.

Indian chintz cloth, eighteenth-century (Victoria and Albert Museum, London)

Indian Chintz

Chintz, chints, chitra, etc, are all different spellings of the Hindi word which was originally used to describe a glazed cotton cloth that had been printed in colours with floral patterns. However, 'chintz' is now commonly used to describe a whole range of printed and woven fabrics, and it is significant that the term 'chintzy' refers in rather a disparaging way to a lifestyle that is characterised by fussy details, a liking for romantic floral Victoriana and the English country-cottage outlook.

It is almost certain that woven and printed cotton and silk cloths were being manufactured in India many thousands of years ago; but it was only comparatively recently, in the middle of the seventeenth century, that examples

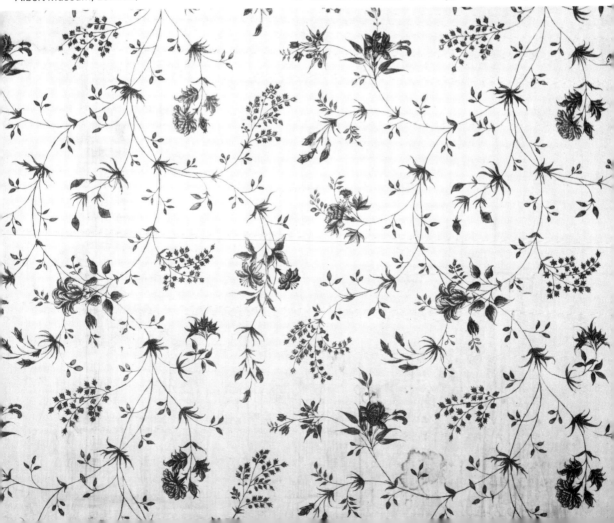

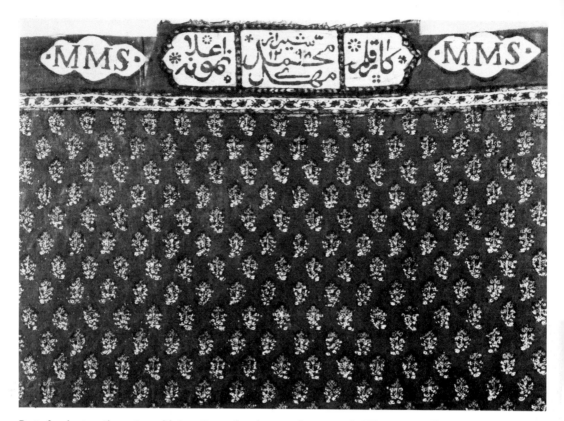

Part of a nineteenth-century chintz pattern, showing detail of edge inscription. A characteristic half-drop design printed in Masulipatam, Madras, Southern India (Victoria and Albert Museum, London)

found their way to Europe. At first, small quantities of the fine printed cloth were brought to Europe by Spanish and Portuguese traders. The fashion-conscious English courtiers and nobles were so taken with the quality of the designs and the fineness of the fabric that they were prepared to pay large sums of money for good examples. In 1630, or thereabouts, the East India Trading Company opened a trading post in Madras with the express purpose of exporting the cloth direct to England. It became in vogue to wear dresses made from chintz and to have the house festooned with Indian drapes. Of course, the fashion very soon reached a point of excess – according to one observer, the people and possessions in rich households were almost totally chintz covered. A contemporary English lady says of the material, 'chintz, pintados and palampores be pretty with flowers and small scenes, with it my chambers be furnished'.

Fortunately for the Indian printers, supply couldn't keep up with demand. England imported more and more of the material so the home wool textile industry began to feel threatened. What it really wanted of course was 'a bit of the action', and consequently English printers began to print imitations of Indian chintz. These home-made chintzes satisfied the poorer end of the market for a short time, but the demand came to an end when the imported material dropped in price. As a last desperate measure to prop up the home industry, influential backers of the English wool textile manufacturers saw to it that imported Indian cotton cloth was banned by Act of Parliament. The moves and counter-moves that followed are absurd: the first embargo wouldn't allow ethnic printed cloth into the country, so the East India Company started sending out English cloth, which was printed and then re-imported. Parliament then banned cotton cloth – the Indian printers reacted by weaving a cloth which had a linen weft and a cotton warp. The result of all these bans was that the demand for the chintz became greater than ever. To satisfy the growing market, the Indian printers were increasingly encouraged to use European block-printing techniques and were also pressured into using colours and materials that were outside their tried and trusted traditions. By the middle of the eighteenth century the quality of the imported cloth had so degenerated that home products were pre-

ferred. Finally, by the end of the eighteenth century both the imported and home-produced material was printed mechanically using harsh chemical dyes and poor cloth; although it continued to be referred to as Indian chintz, it bore little resemblance to the cloth that was originally imported in the seventeenth century.

In the middle of the nineteenth century – by which time the word chintz was used to describe everything and anything that was printed with floral designs – William Morris resurrected the chintz ideal almost, as it were, by accident. He was of the opinion that all crafts had degenerated because of increased mechanisation, and in an effort to ensure that his products were hand-crafted, subtle in colour and significant in design structure, he spent a great deal of his time researching in London museums. When his work is studied, it is evident that he must have been inspired by examples of Indian chintz, even to the extent –

and no discredit to him – that one or two of his prints are direct copies. At one time he was even accused of faking old and antique works. In Morris's workshop wooden blocks were used because they could take the thick, dense, slow-drying natural dyes, instead of the rather insipid colours which characterise fabrics that have been worked with etched metal rollers and fast-drying chemical dyes.

The fashion for chintz or 'granny' fabrics still continues, and they are now considered to be as English as cricket. This feeling is borne out by the fact that many of the Indian Hindi words and phrases that described chintzes have become part of our language.

Bandanna – a particular type of Indian hand-painted cloth.

A block-printed polychrome cotton headsquare. Printed in Genoa, Northern Italy, in 1800, and based on an Indian chintz design (Victoria and Albert Museum, London)

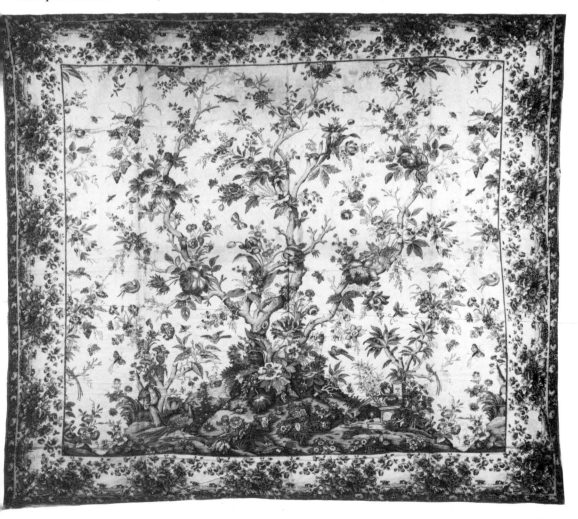

Block printing in the nineteenth century – drawing of an illustration in the Practical Handbook of Dyeing and Calico Printing, *published in about 1870*

Calico – related to Calicut on the Malabar coast, where there was a trading post; cotton cloth imported from India; white unbleached cloth.

Calico Ball – a ball or dance at which the ladies are required to wear chintz or floral dresses.

Pintados – a word originally used by the Portuguese traders to describe chintz and now used to describe many painted cloths.

Palampore – a bedspread of chintz material.

Project 3: Block Printing a Silk Chintz Headsquare

Modern 'chintz' prints come in many designs and colours, so it would of course be possible to print a design that contained, let us say, ten colours. However, the aim of this project is to work in a manner that is as close as possible to the original chintz character. This is complicated by the fact that what we now consider to be the traditional character is actually a mixture of ethnic Indian and seventeenth-century European printing methods and ideas.

As I see it, a chintz design is characterised by simple, floral, two-colour block-print motifs on a plain background. There are of course many old examples of extravagant, multicoloured scenic prints, but for our purposes these must be classified as non-traditional types. The design illustrated (opposite) has been taken directly from an English, seventeenth-century, two-colour print on linen. Designs of this character are ideal block-printing subjects; the restrictions of using two blocks and two colours concentrate and display the efforts of beginners to the best advantage.

Choosing the Fabric
The many hundreds of fabrics on the market, made of natural fibres or synthetic yarns and chemically dyed or otherwise, all have different qualities, good and bad. The choice of material for the headsquare is restricted by the unaccountable behaviour of some man-made fabrics under printing and dye-fixing stresses, as well as by the purpose for which the fabric is intended. With these factors in mind, I have chosen a natural, undyed, unbleached, medium-weight silk. When you purchase your fabric, make sure that both the warp and weft are 100 per cent pure silk and, most important of all, that it is free from any 'special' chemical finish. Failure to observe these points might result in a poor, thin, patchy print.

Building and Preparing a Printing Table
Almost any stable, flat, rectangular table will serve the purpose, but a long wooden-surfaced table or bench that measures about 6 x 4ft is ideal. Once all lumps, bumps and old nails have been removed, the work surface is covered with a thick layer of material that has some slight give – thick blanketing, felt or carpet underlay would be adequate. The soft surface is then

Designing using a single small block. As a print can be organised in a great many ways, it is perhaps best if you experiment until you have a pattern that suits your requirements

covered and protected with a strong, smooth, waterproof material – perhaps one of the plastic-coated American cloths or, better still, one of the smooth plastic vinyls. This top layer is lapped over and under the table edge, and fixed with tacks or staples.

For almost all fabric-printing processes, the waterproof surface is covered with a semi-

permanent, easily washable and replaceable under-cloth; I use a piece of old cotton sheet. Gum arabic (a recipe is given in the glossary) is smeared thinly over the waterproof surface of the table – this can be done with a squeegee, a window-cleaning tool or an old car windscreen wiper – and then with great care the undercloth is heat-fixed with an iron. The purpose of this cloth is to take pins, absorb excess dye and receive most of the wear and tear.

Preparing the Silk and Fixing it to the Table
All fabrics have to be scoured; this is the technical term used to describe the process of cleansing and making ready the cloth prior to dyeing and printing. The treatment varies according to the weight, structure and type of fabric – silk should be brought to the boil in a soft water and soap solution and simmered for a couple of hours; alternatively, you could use one of the special proprietary scouring products now on the market. When the silk has been washed thoroughly, rinsed three times, dried and ironed flat, it can then be fixed to the printing table. Make sure that it is at right angles to the table edges, and then pin or tack it with a needle and thread to the undercloth. If you were using a heavy fabric, like a linen or thick cotton, you could do without the under-cloth and fix the fabric directly to the water-proof and printing surface with gum arabic – iron it on, working from the centre outwards to avoid wrinkles

Registration Grid and Alignment Marks
Registration and alignment marks can be defined as grid or guide marks which ensure an even print coverage. As we are using two very small printing blocks, detailed working guidelines are vital. The surface of the fabric must be divided into a grid that corresponds with the dimensions of the printing blocks. This particular design uses a half-drop grid, which is purposely organised so that the order of printing is staggered. In this way the printing process is continuous and you won't have to worry about printing over areas of dye that are still wet. (Note: there is a precise order of work, please refer to the illustrations.) There are several ways the grid can be drawn – you can use chalk and a T-square, or cotton thread can be stretched across the table at the correct intervals, chalked and then twanged; either of these methods would result in clear accurate guidelines. Remove the threads before printing.

Preparing the Printing Blocks
Printing blocks of many types and grades can be obtained from specialist firms (listed at the

With this design, the cloth has been resist printed and then indigo dyed. By using resists of varying densities you can achieve a blurred or tonal effect

end of the book). Usually they are made from a straight, close-grained wood such as cherry, box, apple or sycamore. Once the design has been considered and completed and a master drawing has been made, it is time to transfer the design to the working surface of the block. This can be achieved by tracing the master drawing and then pencil pressing the design, or better still by mounting the design or at least a tracing directly on the block. The best method is to trace the design using a fine Japanese-type tissue and paste mount this directly on to the wood that is to be worked. Prior to cutting, the tissue tracing can be rubbed with a light vegetable oil until it is transparent and the design shows through (for a detailed account of this process please refer to Project 1). Once the design has been transferred to the block the cutting can begin.

Cutting the Block
Cutting the block is a slow task that requires patience and care; all cuts must be considered, for once the wood has been removed there is no going back. A great many weird and wonderful knives can be purchased, but I personally think

(a) The printing table is built up as illustrated – foam sheet covered by waterproof plastic or film. (b) Gum arabic is spread in a thin layer over the surface of the table

54

(a)

(c)

(b)

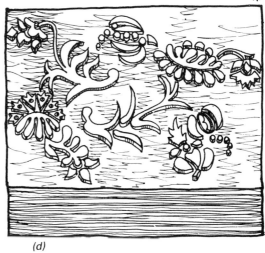

(d)

Designing a repeat for a block print:
(a) Draw out the motif on a sheet of tracing paper and label as illustrated A-A and B-B. Cut the motif in half
(b) Join side A-A to B-B and draw in motifs to fill the space. Trace a complete repeat below your design and, if necessary, fill in with more motifs
(c) Put the complete design back together as in (a)
(d) Trace the design in reverse onto block

that you will be able to work adequately with just three tools: a flat knife of the chip carving type, a V-shaped gouge and a deep U-shaped gouge. You will most probably reach a stage in working when knives of a precise nature will be needed, but these are best bought when you are familiar with the cutting process.

In working, the block may be supported on a sandbag, held against bench stops, or clamped to the bench surface, but remember that it will have to be turned and moved. The lines of the design are cut in, outlining the motifs, at 90°–100° to the printing surface. This angle prevents damage to the fine areas of the block and also encourages sharp printing registration. The knife is held in the right hand (like a dagger) and guided with the fingers of the left hand. When the design has been outlined, the unwanted, non-printing ground or waste has to be gouged out to a depth of about ¼in. In the printing process, the block is rocked slightly from side to side, and there is a tendency for any sharp edges of the cut-away ground to register and make a mark; to prevent this, the low edge ground areas of the block are cut away and chamfered.

Preparing the Block
More often than not the high-relief printing areas of the block are pitted, greasy and not consistently absorbent and so result in patchy prints. There are two ways of dealing with this problem: either the printing can proceed and

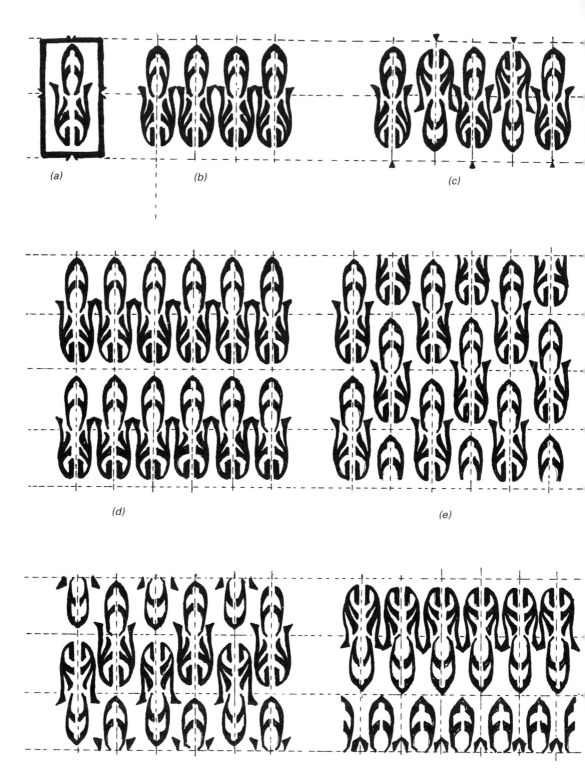

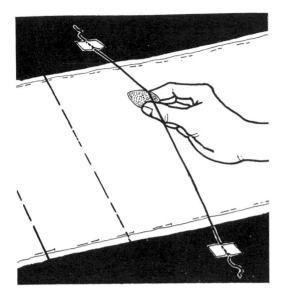

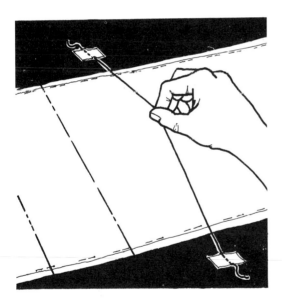

Once the cloth is secure, cotton threads are arranged across it so that they relate to the grid; they are then chalked and twanged. This results in good, clear registration marks – the threads are removed before printing

Possible print arrangements: (a) basic design; (b) simple repeat border; (c) 'top-to-tail' border; (d) simple covering design – rows of motifs; (e) for overall coverage, a half-drop repeat; (f) 'top-to-tail', half-drop repeat; (g) 'top-to-tail' design, half-dropped and fitted

the patchy areas be made part of the overall effect, or the surface of the block can be treated. If the design is 'ethnic' and an irregular print is required, the working surface of the block can be rubbed with a fine glasspaper. This sanding results in a printing surface that holds and absorbs the printing ink or colour and so acts as a reservoir.

Dye Pads, Dyes, Colours, Printing and Fixing
The printing pad can easily be made – in all essentials it is built up in the same way as the printing table surface. A piece of plywood or blockboard about 1ft square is covered with a piece of thick blanket and then a piece of American cloth or vinyl. In use, a piece of flannel is soaked in the colour and placed on the pad, then the movement is: press the block on to the pad – place the dye-charged block on the material that is to be printed – and then strike the back of the block with a heavy mallet or hammer.

The dye types come in all shapes, sizes, containers, colours and chemical compositions, but for this particular project – printing a natural undyed silk – a heat-fixed water-based craft dye is all that is needed. Dyes of this type can be purchased from almost any art supplier. They often come in concentrated form and have to be mixed with bulkers and thinners. (Addresses are listed at the end of the book.)

The block is moved in a staggered pattern across the silk in the order a, b, c, d, e, etc, as shown on page 59; this method of working prevents smudging and over-printing. Once the first colour is dry, and this can be speeded up with the aid of a hair dryer, the second colour can be printed. When both the colours have been printed and are dry, the silk is removed and the dyes are finally fixed according to the manufacturer's instructions. This usually means steaming or hot ironing (see Glossary).

William Morris

Born in 1834 in the small town of Walthamstow in Essex, William Morris was, by the standards of the age, the son of a rich and privileged family. By the time he was nineteen years old it was fully expected that he would enter the Church, and with that in mind he went up to Exeter College, Oxford, in 1853. As he was a rebellious and rather awkward young man, it must be supposed that his first few weeks at college were lonely, but it was during this period that he met two men who were to remain lifelong friends – Burne-Jones and Charles Faulkner. Right from the start the three were anti-establishment in the sense that their literary and artistic leanings were out of pace

(a)

(b)

(c)

(d)

(a) The fully worked design; (b) tracings of the first and second pattern elements; (c) once the pattern elements have been transferred to the block, the motifs are 'cut in'; (d) once the motifs have been cut in, the non-printing ground can be gouged out

(above) *Printed motifs on a dyed cotton cloth. Note the heavily dyed edges of the motifs, and the characteristically patchy areas*

(below) *Grid and order of printing — follow the letters in the top left-hand corner of each full design*

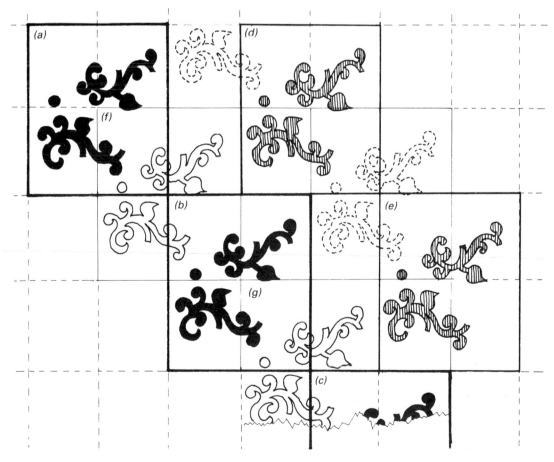

'Chrysanthemum' – a William Morris wallpaper, hand-printed in about 1877 (Victoria and Albert Museum, London)

with the rest of college society. They were incurable Romantics, had a taste for the Chronicles and were artistically inspired by chivalry as described in medieval literature. It was in this climate of swirling romanticism that the group formed a society which was later to be known as 'The Brotherhood'. Although they were caught up in a somewhat minstrelsy clique, the three were also politically motivated by their realisation that life, so far as wealth and power were concerned, was loaded against the poor.

When it was time for Morris to leave college, he knew that he wanted to take up one of the arts, so he rather aimlessly decided to train as an architect. It was during his training that he met Dante Gabriel Rossetti, the leader of the radical Pre-Raphaelite school of painting. At that time Morris was wealthy, young, handsome and absolutely bored stiff with his architectural studies. The flamboyant Rossetti must have come into his life like a burst of sunlight. Morris and Burne-Jones were so completely intoxicated by Rossetti's charismatic

German block-printed linen, early fourteenth century. Although this is a block-printed design, it is almost identical to stencil-worked motifs of the same period

60

Spanish block-printed textile motif, sixteenth century

printed papers, hangings, coloured glass, etc. It was while they were working on furniture and fittings for the house that Morris came up with the idea that they could perhaps influence the direction of the applied arts by setting up a collaborative workshop in which they could design and make all manner of domestic furniture and furnishings that were 'free from false display'. Within a short period the firm of Morris & Co was established. Although, as a co-operative, Rossetti, Webb, Burne-Jones, Madox-Brown and others were prepared to pool their talents, it was Morris who supplied the money and did most of the research and design work.

In 1864–65 the firm moved to Queens Square, Bloomsbury, and Morris began to concentrate his own energies on wallpapers and fabrics. He was unhappy with the block cutting, dyeing and printing processes that were then in use, and he hated the harsh colours of the chemical dyes. He decided wherever possible to take the crafts back to their roots and to rediscover and rework the old formulas and techniques. This often meant

personality that they dropped their studies and decided that they, too, wanted to be painters.

The Pre-Raphaelites believed that after Raphael (1483–1520) Art had entered a period of decline and degeneration; from this premise they declared that if Art was to be reborn, it would be necessary to ignore the work of the seventeenth and eighteenth centuries and to look to ideals that were medieval in spirit and purposeful in practice. Carried along on the crest of Rossetti's dynamism, Morris and his friends Burne-Jones and Madox-Brown became fervent members of the group. Within a few years, Morris was engaged to Rossetti's model, Jane Burden, and Burne-Jones was engaged to Georgiana Macdonald. By 1860 they were all married. Morris was of course rich, so he had his friend Philip Webb, the architect, design and build him a house.

Right from the start Red House was a success, and although it was inspired by medieval architecture, it was by no means a shallow imitative shell. Whereas other domestic buildings of the 1860s tended to be 'Gothic' piles, heavy with unnecessary carvings and ornate façades, Red House was built of plain red brick and the inside had a lot of colour-wash walls and exposed woodwork. As the preoccupation of the group was with all things that were natural and 'within a common tradition of honest building', the members all became very involved in Morris's house and in the need for related furniture, furnishings,

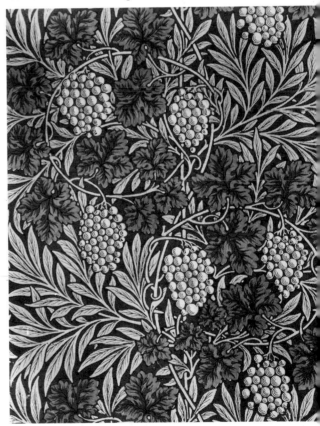

William Morris wallpaper design, 'Vine' – a print from the actual block dated 1874 (Victoria and Albert Museum, London)

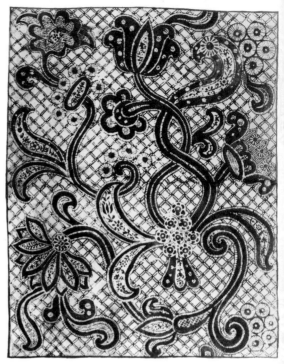

A William Morris printing block for the 'Evenlode' chintz, dated 1883. The nails sticking out of the corners of the block are registration markers (William Morris Museum, Walthamstow)

Seventeenth-century English wallpaper from Kingston-upon-Thames – woodblock printed, black on a natural ground. Very similar in design to black-line dress embroidery of the same period (Victoria and Albert Museum, London)

forging metals, colouring yarns with natural dyes, searching out specific wood types, cutting blocks, making special papers and spending hours on end in museums. From the very beginning Morris had despised all that was mechanical and bogus; if, say, a print, a chair or a stained glass was commissioned, it had to be handworked, every line being naturalistic or direct and having some relevance to structure or design. However, economic survival made it necessary for the firm to make two types of product: the 'stately' and the 'workaday'. Morris always hated the fact that as the firm prospered, so the products became more expensive; it irked him that he was 'ministering to the swinish luxury of the rich'.

By 1871 Morris's two daughters were nine and ten years old, his wife Jane, who was described as being a 'depressive empty head', was living with Rossetti, and Morris himself was flagging under the pressure of work. He was also having trouble bringing together his advanced artistic opinions and his socialistic ideals. On the one hand he saw a world where furniture and objects were handmade, free from pretension and labours of joy and of love; this naturally meant a great deal of hard work

and many hours of patient struggle. On the other hand he saw a world where the common man was free from toil and so able to enjoy simple and honest pleasures; this would be made possible by increased mechanisation. The two views were, of course, incompatible. In spite of Morris's personal problems, the firm continued to do very well. By the early 1880s the name Morris was, as regards wallpapers and furnishing fabrics, a household word. By the end of the eighties, there was such a large range of woodblock, hand-printed papers that Morris couldn't cope, so he handed the production side of the enterprise over to Jeffrey and Co.

By 1890 William Morris had almost burnt himself out, and yet he went on to establish the Kelmscott Press – the culmination, as it were, of his many diverse craft and art activities. Morris was responsible for the overall design conception of the blocks, the border patterns and the type-faces, and Burne-Jones did the

Block-printed line design – printed in black and then hand-painted in red, yellow and green – after a seventeenth-century design from northern Italy

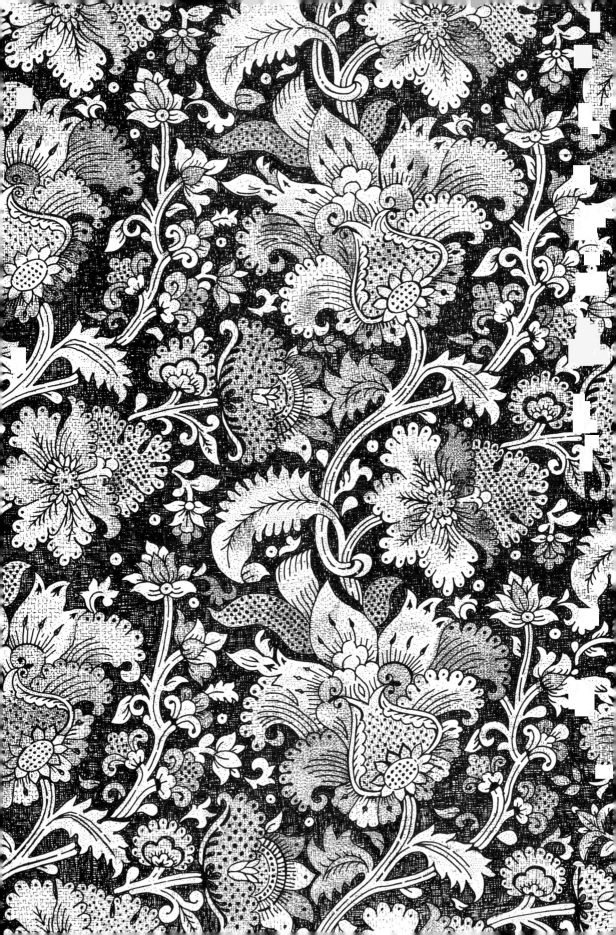

majority of the illustrations. Most of the materials – the paper, inks, colours, etc – were handmade or specially imported, relating wherever possible to medieval originals. Many of the books were inspired by illuminated manuscripts – the work was beautifully expressed and the pattern work was swirling, sensuous and intricate. The immediate result of the press was about fifty titles, the best known being the *Chaucer*. During the 1890s the Kelmscott Press became the pattern for many other private presses in England, Europe and America, and of these a great many found expression in the woodcut. Although Morris died in 1896, his work, especially his printing, continued to be a motivating influence well into the twentieth century and, to give Morris the last word, showed that 'work of utility might also be a work of art'.

William Morris's original design for the wallpaper pattern 'Acanthas', dated 1875 (Victoria and Albert Museum, London)

An original photograph which shows two of William Morris's printers at the Kelmscott Press, working on the Chaucer *– dated 1895. Note the stack of paper ready for printing, and the Hopkinson press* (William Morris Museum, Walthamstow)

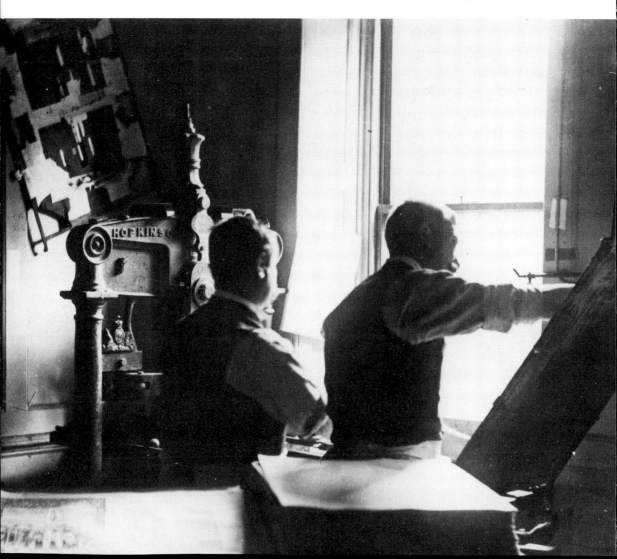

A woodblock cut by Lucy Faulkner after a design by Burne-Jones to illustrate William Morris's 'The Story of Cupid and Psyche' from The Earthly Paradise

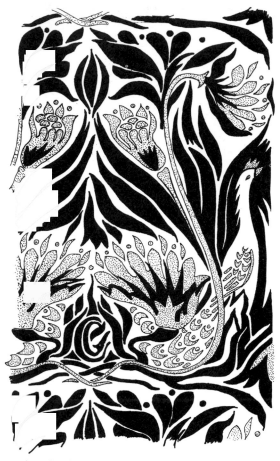

A design for a block print in two colours, inspired by A. H. Mackmurdo's 'peacock' print dated 1882. Mackmurdo lived for almost a century, 1851–1942. He trained as an architect, studied under Ruskin, extended the traditions of William Morris, and founded the Century Guild for Artist Craftsmen

Project 4: Block Printing a Curtain or Blind

In the latter half of the nineteenth century William Morris revolutionised the colour, shape and design of domestic interiors with his printed fabrics and wallpapers, which were considered to be artistically forward-looking in design and adventurously romantic in concept. The majority of his designs were floral, chintz related and multicoloured, the motifs tending to be delicate, entwined and naturalistic. Many were inspired by his love of medieval literature, art and the Viking and Icelandic sagas. Of course, as with all the crafts, the designs cannot be looked at in isolation – they must be related to the processes and techniques. And the printing of successful wallpapers and fabrics depends almost entirely on the designs being fully considered and the

repeats being well linked. As an accomplished artist and craftsman, Morris was able to work comfortably within these restrictions, and it is perhaps for this reason that the majority of his designs were so successful.

There are several ways in which this project could be approached – for example, you could design and print a wild chintz that contained 'Morris' motifs, or you could copy an actual design stroke by stroke. However, I don't think that you should be too ambitious at this stage – just look at the style and adapt. I have chosen to take a single floral motif from the Morris tradition and to print it in one colour as a repeat border. Concentration on one small element of design should enable you to come to terms with the subtleties of Morris's lines and forms and, at the same time, develop some degree of craft understanding and appreciation.

Choosing the Material
The choice of material will depend on whether you are going to use it for a roller blind or curtains. (Note: if you choose a coloured material, make sure that the colour is fast.)
Curtain Material As far as the actual printing process is concerned it might be as well to choose a closely woven, medium-weight cotton, linen or silk; if you use a natural fibre rather than one which is man-made, then at least its behaviour under printing and dyeing stress will be predictable. You can of course use a closely woven, heavy-weight material – a good idea if you want winter curtains – but if the yarn is bulky, lumpy or slubbed, the printed design will be fuzzy-edged and clumsy. An ideal material for printing with blocks should be smooth and dense.
Roller Blind Because of the action of the roller blind, the material used must be lightweight, fine and smooth.

Building and Preparing a Printing Table
You could, if you wished, use the equipment described in the chintz headsquare project, but I'm suggesting slight variations in printing method and set-up in order to broaden your understanding of the craft. As the pattern to be printed is in the form of a strip or border, the printing table need only be long and plank-shaped; in fact, if you want an immediate surface then you could use an ironing board. Cover it using a sheet of fine plastic and sticky tape, and then stretch an old piece of cotton sheeting over the plastic and pin it so that it is taut. The average ironing board is in nearly all essentials a perfect printing surface – long, smooth, steady and resilient.

A William Morris inspired border design for the window-blind project. Although at first sight this design might look difficult to cut, it is in fact very straightforward

Design for the curtain/blind in the William Morris character

A William Morris inspired design – difficult to cut. It could possibly be worked in two colours

A basic border print – simple to work and easy to register

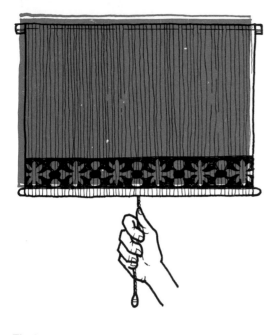

The border print in context

Preparing the Fabric Prior to Printing

In all fabric-printing processes the material must be scoured or washed before it can be worked, and this usually means bringing it to the boil in a soapy, soft water solution and rinsing it at least three times. This preliminary process is time consuming and boring, but it is vital if you are to avoid patchy and disappointing prints. In the manufacture of many woven and printed fabrics, the producers 'finish' the cloth in an effort to make it more attractive and marketable; in most cases this 'finish' consists of a chemical soak or starch. Consequently, if you printed a piece of material that contained a lot of finish, the printed dye would sit on the surface and after a couple of washes the print would deteriorate and perhaps disappear altogether. Once the fabric has been washed and rinsed, it can be ironed and cotton tacked to the printing table.

Cutting the Block

This is such a small print that the cost of the wood for the block will be minimal, and it may even be possible to improvise and buy an offcut from a local wood merchant. The choice of wood is a personal matter – some cutters insist on using lime, but most straight-grained fruit woods are suitable. As you can see the pattern forms are relatively basic, but I have tried to achieve a balance between printed and non-printed block surface. With this particular print, it is the areas surrounding the design that are to be left in high relief and so do the printing.

If you have confidence in your drawing ability the design can be worked directly on the block; but if you have any doubts, you would be better advised to work it out on paper with a brush, pen and Indian ink, and then transfer it to the block. Some cutters like to take the design to a finely worked and considered drawing, others prefer to work it out in rough and then bring it to a fine finish on the blocks. In either case, the surface of the block has to be prepared. The important thing is that the wood should be textured and coloured so that the pencil marks are visible and the surface is rough enough for the pencil to grip. The most straightforward method of achieving this is to rub the wood with a small amount of white water-colour paint. If too much paint is applied the pencil point ploughs up a white powder, and if too little is used, contrast is poor and the pencil lines are smudgy and faint.

Once the drawing has been finalised on paper, it can be transferred to the whitened block. Make a careful tracing of the design, turn it over and then place it on the working surface of the block, making sure that it is firmly taped into position. The reverse side of the tracing paper can now be gone over with a hard pencil. When the tracing paper has been removed, the design can be further worked. It would be as well, at this stage, to follow the practice of some cutters and black the areas of the block that are to print. This does ensure that the design has been understood and finalised; it is also helpful if you know that you

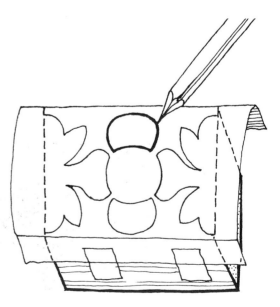

The traced design is pencil pressed on to the working face of the woodblock. The tracing paper is held in place with masking tape

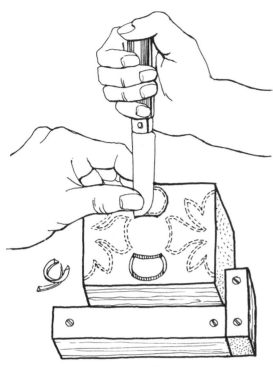

When you are cutting the block, it must be supported against bench stops and the cutting blade must be guided

The block cut and ready for printing

are only supposed to be cutting away the white areas.

Once the design has been satisfactorily transferred to the working surface of the block, the cutting can begin. The design is, first of all, outlined with two cuts of a very sharp craft or specialist block cutter's knife, so that it is surrounded with a V-shaped trench or furrow. The knife can be held in the Japanese manner like a dagger and then drawn and guided towards the body, or it can be held and used like a pen. Either method is satisfactory; the important thing is to develop a way of working that gives you full control of the blade. It doesn't matter which hand you use for cutting as long as the blade is worked with one hand and guided and manoeuvred with the other. The amount of pressure put upon the blade will vary from wood to wood. When you are cutting across the grain you will be able to feel areas of hard and soft wood growth, and as these areas are crossed there will be a tendency for the blade to slip and jerk, so be extra careful. When the design has been cut in to a depth of about 1/4in, the areas of ground or waste wood have to be removed with a gouge. If the design is small and fine lined, it may be necessary to clear away the wood with small lino-type gouges and specialist block cutting tools. In the design illustrated, you can see that the white areas,

which are to be cut away, are well defined and relatively simple in form – it is most important that your design doesn't run ahead of your block cutting ability.

Printing the Block
As in the case of most craft processes, a mystique has grown up around the technique, and yet the method of working is relatively simple. Ink is applied to the high-relief surface of the block, and then the block is pressed firmly on to the fabric or paper. There are all sorts of complex presses, mangles and lever systems, but if you concentrate your efforts on the design work and block cutting, the actual printing will almost take care of itself.

To make a printing pad, place several pieces of fine cotton sheeting in the lid of a cake-tin and then coat them in the printing medium. Don't swamp the complete tray, just spread a little colour on the pad and have a trial print. The procedure is as follows. Press the block into the dye pad, then place it on the fabric so that it registers and strike it with a mallet. With this particular project the method of registration is straightforward – parallel lines are drawn across the fabric with chalk and then the block is printed head to tail across the material. If the design has been successfully worked and cut, the coloured background of the repeated print will appear as a continuous unbroken band. Once the printing has been achieved, the fabric can be steamed or ironed according to the dye-maker's instructions.

Hints and Tips
The design of the print will have to be scaled to fit the width of the fabric. Make sure that the printing medium is emulsive – if the colour is loose and runny the cut-away areas of the block will fill up and a bad impression will result. If the printing pad is too thick and spongy, the block will take up too much colour; the pad should be firm.

69

PART III
STENCIL PRINTING

STENCIL PRINTING

Stencil comes from a French word meaning to sparkle, to cover with little stars. In craft stencilling a thin sheet of card or wood is pierced in a manner that relates to certain design requirements; the stencil plate is then placed against the surface that is to be decorated; and, finally, coloured pigment is pushed through the holes of the plate. The stencil technique of pattern transference or printing is often used in conjunction with block printing to decorate wallpapers, hand-printed textiles, furniture, room interiors, signs, etc.

Japanese Stencil Printing of Cotton Kimonos

Japanese crafts are renowned for their intricacy, delicacy and integrity, many of them being so thorough in design conception and technique that we in the West think of them as unique. One of the crafts that the Japanese have mastered and taken to such heights of perfection is that of cutting and printing with stencils. The basic idea is, of course, simple enough – cut holes in metal, paper, wood or card and brush paint through them. The result of working in this way is often the crude splodges that are used for marking packing cases or whatever. In Japan, however, the designs achieved are so incredibly fine and sensitive that they appear to have been carefully block printed or meticulously hand-painted. It is only by looking at the process in detail that we can come anywhere near to appreciating the skills and technical know-how that lie behind the craft.

The art of stencil printing cotton cloth seems to have become established in Japan in the sixteenth and seventeenth centuries, when it became fashionable to wear light cotton kimonos. The shogun, or ruler, was busy restricting the wearing of costumes that were produced by extravagant means, that is silks and embroideries, but the influential middle classes wanted flamboyant clothes, so ingenious printers rose to the occasion. Stencil printers developed the process of printing both sides of cotton cloth in order to imitate double-woven and embroidered silk. Although block printers could print on cloth, it was only the stencil

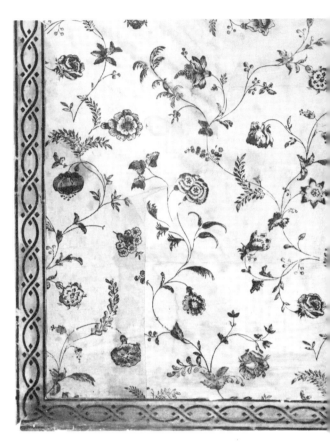

English wallpaper, late eighteenth century – blue floral pattern with borders on two sides. This wallpaper from Uppark has been block printed and stencil worked. The stencilled border is an added strip or dado, and is, in character, very much like American stencilled work of the same period (Victoria and Albert Museum, London)

printers who were able to reverse their stencils and so produce an image and mirror image, and this was vital if both sides of the cloth were to be identically worked. (A kimono is a loose robe that is bound round the waist with a sash; both sides of the material are at times visible.)

In Japan, craft activities are grouped so that whole villages or communities concentrate on all aspects of a single craft – there are pottery, weaving, iron-working and printing

73

Stencil plate showing the registration 'windows'. These cut-out key windows relate to elements of the design, and they are used as alignment aids only

Border stencil design showing the finished repeat

communities, all intent on making traditional products. It must be pointed out at this stage that Japanese craftsmen rework or directly copy old designs – they believe that to use a piece of work or a design which belongs to another craftsman or period is to give that work special credit. And so it is that there are villages in Japan given over almost entirely to the stencil printing of traditional cotton kimonos.

At a glance, the Japanese stencil plates or cards look so fragile that it seems amazing that

they remain intact. However, on close inspection it can be seen that within the structure of the plates there are reinforcing strands of silk or hair. Early European observers described the stencil makers as either splitting the plates after they were cut and then inserting the threads, or putting the threads in individually with a needle. Neither of these ideas would be practical and both are misleading. When the stencil cutter receives a commission for a stencil, he sets about preparing a special stiff waterproof card. Each stencil card is made up of two or three sheets of white mulberry paper, the long fibres giving strength and resilience. Once the sheets of

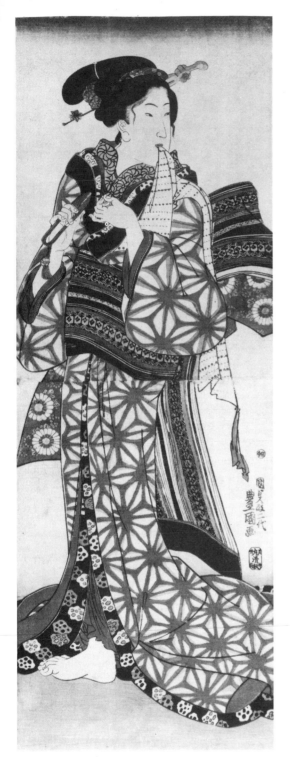

Japanese block print by Kunisada (1786–1865), 'Girl with Nailclippers'. The type of costume illustrated would almost certainly be stencil and block printed (Victoria and Albert Museum, London)

paper have been pounded together, they are soaked in tannin and then put in a smoke-house. After some considerable time of being suspended in a wood-smoke atmosphere, the paper becomes a stiff, brown, almost leather-like material, not immediately recognisable as card. The cutter takes a tissue paper tracing of the master design, and sets about transferring it to a single stencil card. When he is sure that the design has been satisfactorily worked, he takes a stack of eight or nine cards, places the design card on top of the pile and begins cutting. In this way he makes a number of identical sheets. He cuts with apparent ease, confidence and great speed, using a short-bladed knife and working much like the woodblock cutter. The knife is held firmly in the right hand and guided with the thumb and index finger of the left hand; sometimes it is pushed away from the cutter and sometimes it is worked forwards in a stabbing motion – there doesn't appear to be any set way of working.

There are two distinct methods of reinforcing the stencil plates; the first is as follows. The stencil plate is worked and cut until it is almost complete, but the main bridges of the design are left intact. Once the cutter is pleased with his work, he carefully pastes a sheet of tissue paper to the back of the plate; this acts as a temporary support and strengthener. When the tissue is dry, he cuts away the remaining bridges. The plate is now completely cut and is only prevented from falling to bits by the tissue-paper backing sheet. The next stage of the process is rather tricky. Lacquer is brushed over the working face of the stencil plate and a fine web of silk is placed in position. The sticky mesh is manipulated with a wooden pointer to ensure that all the little bits and pieces of the stencil plate have been covered. Once the lacquer is dry, the pasted tissue at the back of the plate is dampened and then carefully rubbed and peeled away. Obviously, as the whole thing is incredibly delicate, this process can only be managed by someone who is very experienced.

The second method of reinforcing a plate is rather more complicated. The plates are cut and prepared as before, but it is always an even number of cards that are worked. Once the cutter has completed his task, he groups the cards in pairs, then each pair is taken and pinned to a board so that it is hinged rather like a book (with the tissue on the outsides). This 'hinged book' is opened and individual lacquered threads are inserted. Once all the parts of the design have been caught up in the sticky web, the two plates are further lacquered and then pressed together sandwiching the threads. Again, once the paper is dry, the tissue

75

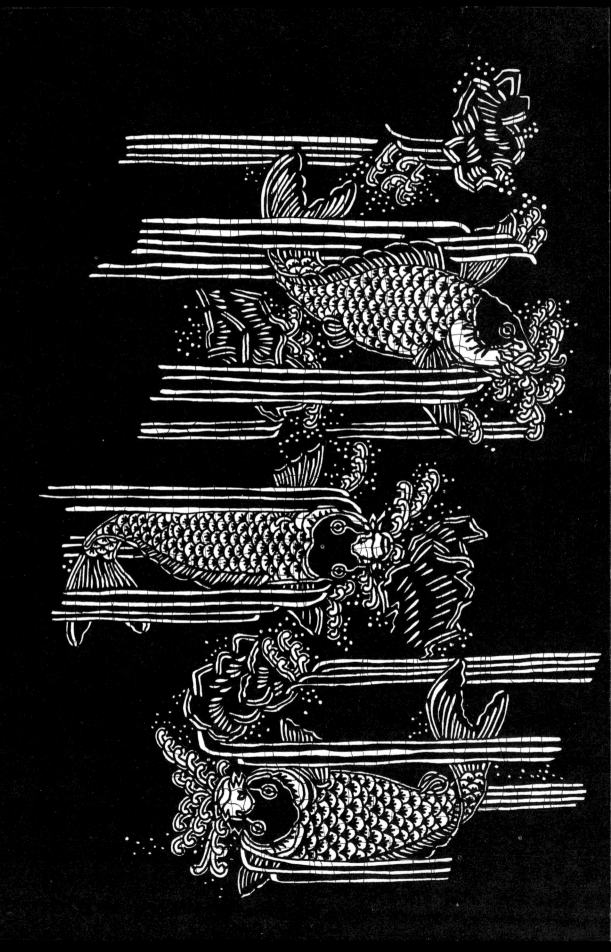

Part of a Japanese stencil plate called 'Hairy-tailed Tortoise' (hairy tail, in the Japanese context, symbolises longevity). Note the reinforcing stencil-plate fibres

Japanese 'Fire Fly' stencil design for textile printing

Japanese floral design for a kimono print

Japanese 'Carp and Cataract' stencil plate. This illustration shows the complete plate, which repeats top to bottom and side to side

Traditional nineteenth-century design for a Japanese stencil plate

Traditional Japanese design for a cut-and-punch stencil

Japanese bird design for a cut-and-punch stencil

white motifs. The process is as follows. A board is used that is slightly wider than and half as long as the kimono length of cloth that is to be printed. After being dampened, the cloth is ironed on to one side of the board, wrapped over the end and ironed on to the other side. The board is then rested on a couple of trestles in readiness for printing. The printer positions the stencil plate and then, using a spatula, pushes a coloured paste resist through the plate on to the cloth. There are two points that must be appreciated: a paste resist is a printing medium that, when dry, will prevent dye penetration, and it is coloured so that the printer is able to see where he has worked. The process of positioning the stencil plate and pushing through the paste resist is continued until the cloth on one side of the board has been printed. When the paste is dry, the cloth on the other side of the board is worked in a like manner. Once the paste on this side is dry, the cloth is peeled from the board, turned over and then printed on the other side, the only differences being that a different coloured paste is applied and the stencil plate is reversed. Obviously, the second printing is slower than the first because the stencil plate has to be aligned with each motif on the other side of the cloth. Once the cloth has been inspected by the master printer, it is handed over to the dyer. The dyer stretches the cloth by springing spiked bamboos across its width; it is then brushed with a paste-fixing solution, steamed, and lowered into the dye vats. The dye penetrates the cloth but is resisted by the areas that have been printed with the paste. Finally, the material is washed in flowing water until all traces of paste and dye have been removed. The end result of all this effort is a fine cotton cloth that is identically printed on both sides, the effect being that of double-woven or embroidered cloth.

Project 5: Stencil Printing a Dress Length

This project is designed specifically for those who would enjoy the challenge of attempting a craft process of painstaking intricacy. The object is to design, cut and stencil print a border pattern on a length of dress material. I have in mind either a length of fine silk, cotton, linen or calico that could be made up into an evening dress, or a dress which you already have and would like to remodel visually. I am primarily going to describe how to print the material that has yet to be made up, so if you envisage printing on an existing dress you will have to adapt the technique slightly.

The stencil-printing method I have chosen is

is dampened and carefully peeled away. The process may sound relatively simple, but unless the worker has a very thorough knowledge of mixes, amounts and consistencies, any number of things can go wrong.

Once the plates are dry, they are ready for printing, and this is done by a separate craftsman. The technique most commonly used is that of printing a resist paste and then dyeing the cloth a base colour; this results in, say, a blue cloth covered in stencil-printed

78

of the punched hole variety and is therefore characteristic of traditional nineteenth-century Japanese stencil work. Of course, the actual shape and inspiration for the design need not be Japanese. There is a strong mechanical influence in this technique, as the holes are all worked with round section metal punches. The shape of the tools is bound to be a major design factor, but this must not be allowed to dominate the pattern composition; as you can see from the illustrations, the resultant pattern motifs can be beautifully free and flowing.

The Choice of Fabrics and Pre-Printing Preparation

It is most important to choose a material that is natural, closely woven and light in weight and colour. I have suggested cotton, silk, linen or calico. If it has already been made up into a dress, worn and then cleaned, I think you can assume that all the finish has been removed. If, on the other hand, the cloth is in a length, it should be scoured prior to pattern cutting. The process is relatively simple and has been covered in other chapters, but just to recap — wash the fabric gently in a soft water and natural soap solution, then rinse it thoroughly

Traditional Japanese 'Peony' stencil design using punched dots

several times. When the fabric is dry, iron it so that it is smooth and free from creases.

Building and Preparing the Printing Table

If you are going to print on a dress that is already made up, you will have to use an ironing board as a printing surface (see Project 4, on printing a curtain blind). If the fabric exists as part of a cut-out pattern, then it would be better to make a purpose-built surface. As the amount of time spent actually printing is minimal, then all you really need is a temporary, flat, resilient waterproof surface. Let us say that you are going to use the kitchen or dining-room table. First, cover the surface with at least five layers of newspaper; then cover the newspaper with a thin sheet of uncreased plastic; and finally, cover the whole lot with a piece of old cotton sheeting. Obviously you can't start banging staples, nails and pins into your favourite table, so you have to either gather the sheeting underneath the table top and pull it together with huge stitches, or hold it in place with sticky tape. Once the table is ready, the fabric to be printed

A small motif for the dress or gown bodice. The dots represent the punched stencil-plate holes, so, if the plate is to have any strength, the holes must not be closer than about ⅛in

is smoothed on to the sheeting surface and held in place with tacking stitches.

Print Registration and Designing
Registration is achieved by matching up certain holes in the stencil plate. If you look at the illustrations, you can see that the composition is organised so that the link-up or break in the repeat is almost invisible. This is achieved by drawing out the design in rough, cutting the rough design in half, placing the two halves so that they are positioned edge to edge, linking and relating the two edges, and then finally rejoining the design middle to middle. Once the design has been finalised on scrap paper, it can then be transferred to a good quality tracing paper.

Cutting the Stencil Plate
A special paper or card can be obtained that is specifically designed for stencil cutting; it is tough, waterproof and resistant to warping. But if, like me, you have difficulty finding a

A dress-print design inspired by European Art-Nouveau forms

The large motif for the hem of the gown. The dotted lines frame a repeat, and the ringed holes are used for registration – the repeat is from side to side

An idea based on holes of different sizes

supplier, it is very simple to make your own card. Get a good quality cartridge paper, give it several coats of varnish and then peg it on the line to dry. The result will be the most beautifully, shiny, transparent, almost 'vellum'-type card, well worth the extra effort and expense. Bear in mind that you will need two pieces of card for every stencil plate that you intend making. For cutting the actual holes you will need a variety of hole punches, which can be obtained at leather shops, art shops, sewing shops, camping shops, etc. They are, in effect, little metal tubes that have been sharpened at

An idea that could be used for the gown hem. The dotted line marks a repeat, and the large corner holes are used to aid registration; the heavier large-dot border can be as deep as required

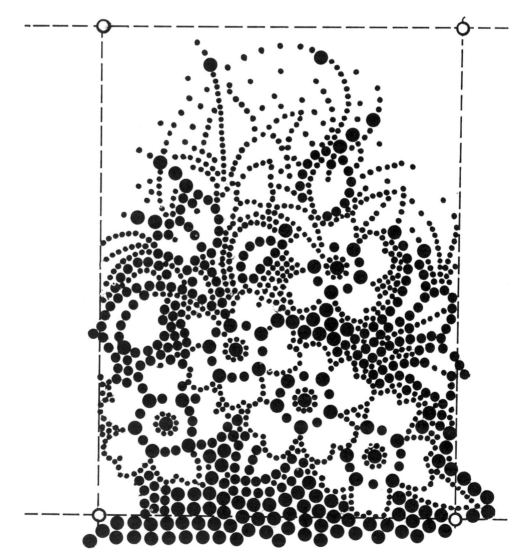

82

one end; to use, they are held vertically and smartly tapped with a hammer.

In working, two sheets of stencil card are taped together down one edge, the traced design is placed on top, and then all three pieces are taped onto a smooth piece of scrap board. The design is then punched out, making sure that the holes are no closer than about ⅛in. When the design has been worked to your satisfaction, the two pieces of card are opened up like a book and lightly coated with a petroleum-based gum. A made-up mesh of cotton fibres or silk strands is then placed on one of the gummed surfaces, and finally, making sure the holes match, the two cards are carefully pressed together, sandwiching the strengthening fibres.

Two pieces of stencil card are placed together and taped so that they open like a book

Printing

Once the cloth has been attached to the printing table and the plate has been cut, you can proceed with the actual printing. You will need some stencil brushes – these come in all shapes and sizes, and most artists' suppliers have them in stock. The stencil plate is positioned, making sure that the registration holes are related to the base line, and then it is secured with stainless-steel dress-making pins. The brushes, which are short haired and stiff, are dabbed in the printing medium, and then dabbed vertically through the holes in the stencil plate onto the fabric. The amount and consistency of the dye taken up on the brush is critical – it needs to be thick, almost dry – and it might be as well to have a trial run on a piece of scrap material. As the stencil plate is so very fragile, it is vital that the brush action is vertical; if you try dragging the brush from side to side, dye will be forced under the plate and the design will bleed and run; the delicate 'bridges' of the plate might also break. The density of the colour is built up over several dabbed applications, so it is possible to have multi-coloured, merged and graded effects. With each dabbing, only just enough colour is taken up to produce a pale streak if the brush is drawn across the back of the hand. It might be worth experimenting with some spray-applied dyes – there are some well-designed garden plant sprays on the market, and if the dye medium could be used in the liquid rather than the paste state, these could well be really useful.

Finally, when the stencilling is complete, the print can be fixed according to the dye-maker's instructions.

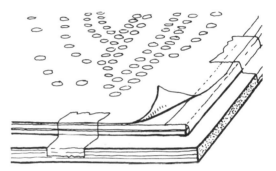

A tracing of the master design is placed over the sheets of stencil card, and then this 'sandwich' is taped on to a flat wooden board

Cutting or punching the holes – a sheet of very thick tin-plate or a sheet of plastic also makes a good cutting surface.

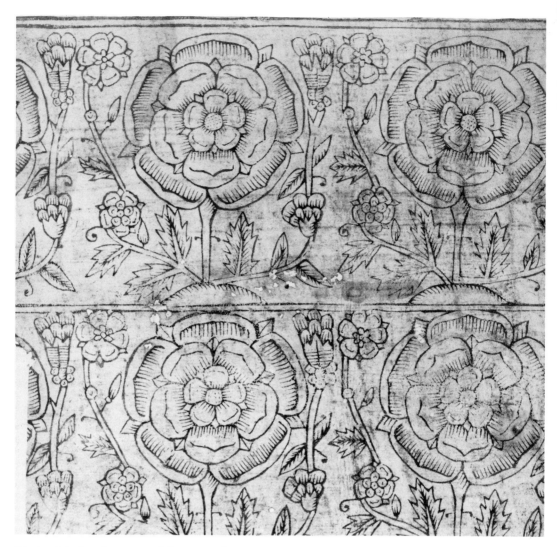

Block-printed wallpaper or lining-paper fragment, English, sixteenth century. The Tudor rose was a favourite decorative motif of that period

Project 6: Stencil Printing a Box Lining or Wrapping Paper

This project is designed for those who want to work and print a personalised box lining or wrapping paper. We are going to stencil print a single motif so that it fits a regular grid and covers a sheet of quality hand-made paper. The designs used in this project draw their inspiration from the few surviving examples of medieval stencil-worked panels that can be found in churches in the eastern counties of England. These stencil-worked and painted wooden panels are usually to be found high up on inaccessible screens and ceilings. Many of the motifs used on these stencil-worked panels

have an Eastern flavour – so it is probable that the medieval stencil workers were in their turn inspired by the carpets, tapestries and fabrics which were at that period being traded across Egypt, Morocco, Spain and Europe and which were gradually finding their way into wealthy English homes. Usually the stencil-worked patterns were used as a backdrop for the more prestigious work of the painter or carver. So, for example, the drapes that are painted as a background on a picture of St Peter might be regularly patterned with repeated stencil motifs. Many old accounts refer to such paintings as 'pretty paintings that be patterned with flowers'.

I don't want you to copy the old patterns but

you should be attempting to achieve a design that evokes the medieval stencilled imagery. Think in terms that might be described as heraldic. It is essential that the shapes are bold in design, naive in composition and practical in working; your enthusiasm for the task must not result in fussy minutiae.

Designing the Motif

As the positive areas of a stencil plate are in fact holes, one of the main design considerations must be to avoid cutting away so much card that the remaining areas are insufficient to hold the plate together as a single structure. The strength of the design can be improved by careful planning of the 'bridges' – these are the thin areas of the card that span the holes of the design, appearing as negative non-printed areas on the printed motif.

Once you have in mind the shape that the motif might take, it is necessary to get your ideas down on paper, and this in itself is no easy matter. As stencil designers, we are talking about holes that print a solid area, rather than a thin drawn line; it is for this reason that the best design tools are brushes and ink and definitely not pens and pencils.

The Stencil Plate

Once the design has been worked to your satis-faction and meets the various craft demands imposed by the stencil technique, it can be transferred to the plate. The master design is traced and then the traced design is pencil pressed on to a sheet of thick cartridge paper. When the design has been inked in, the paper can then be given a coat of clear plastic varnish.

It is essential that the cut edges of the stencil plate are clean and without burrs, and to this end the actual cutting is done on a thick sheet of glass. In working, the stencil plate is cut through in a single stroke; the craft knife is drawn towards you with the right hand while the stencil card is manipulated with the left. When cutting the curves, the knife is drawn slowly forward and the card gently turned so that the line of the next cut is immediately in front of the moving blade. When the stencil has been satisfactorily and finally cut, it can be given another two coats of clear varnish.

Note: as it is necessary to do all the cutting on a sheet of glass, the knife will need frequent resharpening, so have either an oilstone or a good supply of spare blades at hand.

Ideas for motifs that have their roots in English church stencil decorations of the sixteenth, seventeenth and eighteenth centuries

(a)

(b)

(c)

(d)

The Printing Table

As the printing process is relatively simple and you are only printing a few easily manageable sheets of paper, I think you could work quite comfortably on a drawing board that has been padded with newspaper. The paper that is to be printed can be held in place with drawing pins or masking tape.

Choosing the Materials

As this project results in a handful of almost exhibition sheets of printed paper – a limited edition – then it is a good idea if the paper to be printed is exciting both visually and texturally. In my experience, the material best suited to this task is one of the Japanese or Indian hand-made mulberry-fibre tissue papers. In addition to the qualities already mentioned, a paper of this character has a great deal of wet strength.

Registration Marks and Printing Grid

Although the design consists of one main motif cut in a single plate, the resultant composition will be continuous and one of total coverage. It is therefore necessary for the order of printing to be worked out so that each pull or print of the stencil is in a carefully considered and linked sequence. First a printing grid is designed, and drawn on the paper with a soft pencil and then, to aid the tying and linking of repeated motifs further, key 'windows' are cut in the stencil. These windows will not be printed – in use they are aligned with a portion of the previous print. This preparation will ensure that the printed motifs relate precisely.

Printing and Working Method

With all craft processes it is important to be organised and methodical, so it is worth giving the order and rhythm of working a great deal of consideration. The printing arrangement or set-up is as follows. The drawing board is placed on a good, solid, flat, steady surface, say the kitchen table, and all the materials – paper,

Designing a stencil motif that is plant inspired:
(a) First the plant is sketched
(b) Single design elements are lifted from the original study and organised so that they relate to some pre-conceived grid or format
(c) Once the major design elements have been set up on the grid, they are further drawn, pulled together and worked until finally the motif or pattern meets your design demands
(d) The areas of the design that are to be cut away, are blacked in and the stencil 'bridges' are positioned so that they occur at natural crossing points. Although these 'bridges' are a technique requirement, if they are fully considered they give the design strength. Flowers and leaves are good stencil subjects because the veins and joints are, as it were, nature's 'bridges' or design structures

dye pad, brush, sponge, etc – are placed close at hand. Immediately prior to printing, the paper must be slightly dampened. This is a bit of a nuisance, but it is very important and must be done carefully; if the paper is too damp it is inclined to break and resist dye, and if it is too dry it will suck up vast quantities of dye and be spongy. The method of damping is as before, the printing paper being placed between sheets of damp paper – three printing sheets, one damp sheet, three printing sheets and so on.

Once the work table has been organised, a sheet of gridded and dampened printing paper is pinned out on the drawing board, making sure that it is positioned square with the board. In working, the stencil plate is held in position with the left hand, while the special short-bristled brush is held vertically and dabbed up and down with the right hand. As far as possible, the dye or ink should be used almost dry – it should be necessary to dab repeatedly to build up an adequate density of colour. The particular joy of this stencil method is that as the density of ink is variable, it is possible to grade, merge and fade the colours and so produce tonal and multicoloured effects. As there is a tendency for the stencil plate to buckle and warp, it has to be pressed down firmly so that the area that is being worked is always in contact with the printing paper. When you have applied the colour, don't just drag the plate away – put the brush down, making sure that it isn't going to roll across your work, then with great care and still maintaining the pressure with the left hand, gently raise one corner of the plate, and then finally lift it in one upwards movement. If the colour is used almost dry, as recommended, you will be able to repeat the printing procedure immediately after you have sponged down the plate. For all subsequent printings you should be able to position the stencil plate so that the key or registration windows are aligned with previous impressions. If, for example, you start at the bottom left-hand side of the board, move from left to right, and finish at the top right-hand corner, you should always be relating to the print that has just been done.

Comments, Hints and Tips

With the designing and printing of stencil plates, the positioning and size of the bridges or ties is critical. If these ties are too thin they break up under printing stress, if they are too thick they become a design intrusion, and if they are placed at random they are never satisfactory.

Design link-up can be achieved by stretching cottons in a grid across the paper that is to be printed. In working, the marked stencil plate is

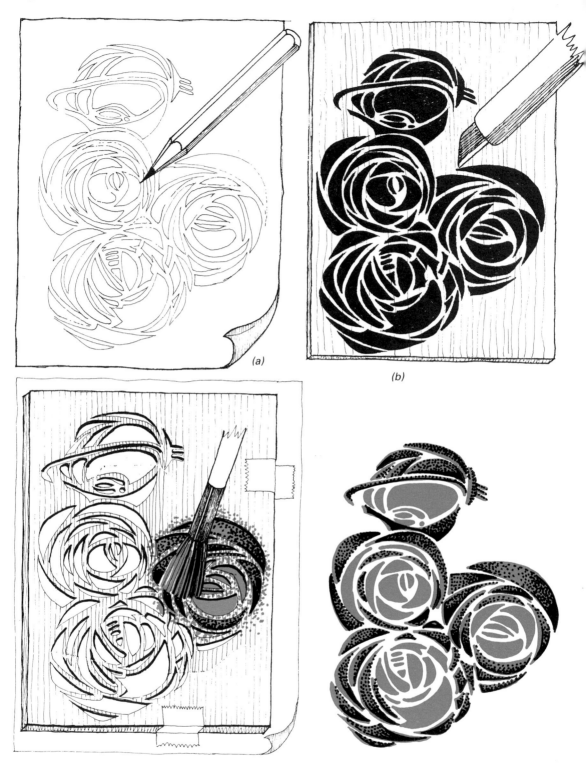

(a)

(b)

(c)

(d)

In cutting the stencil, the card is manipulated with the left hand while the knife is guided with the right. A sheet of plate glass makes a good cutting board, but the knife will need frequent resharpening

The drawing board is padded with several sheets of newspaper, the paper to be printed is held in place with masking tape and the grid is marked by cotton threads. The stencil plate is placed between the paper to be printed and the cotton grid markers

Cutting the stencil plate:
(a) Once the design has been fully considered it is traced
(b) The tracing is pencil pressed on to the stencil plate, and then the 'windows' are cut away with a fine craft knife
(c) The worked stencil plate is positioned and secured, then the almost dry pigment is brush applied
(d) The stencil design should be based on cut-away windows

placed and aligned between the paper and the threads (this is an alternative registration method).

If you want a shaded effect, there are two ways of working: you can, as already described, build up colour density with repeated brush dabs, or you can use the three-brush method. For this technique you will need three saucers and three brushes. In the first saucer mix the base colour with just a hint of white; in the second saucer mix the base colour thick and almost dry; and in the third saucer mix the base colour with just a hint of black. In stencilling, work from left to right using the colours in turn; this will result in a printed motif that appears to be three-dimensional, tonal and shaded.

American Colonial Stencil Decoration

There exists in America a peculiarity of arts and crafts style that is most easily described as 'home-made' or 'homespun'. Generally, this style is characterised by colonial homestead furniture and New England house interiors. Within this movement, stencil decoration is uniquely placed, historically and technically. There are all sorts of suggestions as to just how the tradition of stencil decorating furniture and interiors developed. Of course, in a manner of speaking the craft was a totally American product, but it is also quite logical to suppose that this particular form of decoration had its roots in Europe and maybe the East.

In the seventeenth and eighteenth centuries, millions of emigrants from England, Sweden, Norway, Central Europe and the East were leaving their homelands and building new lives in the American wilderness. It is on record that these settlers travelled light. Naturally, they retained a romantic cultural image of their homelands and their traditions, but as far as concrete objects were concerned they were definitely limited to very small items of sentimental value. So within an American colonial community of this period, there might be French and German families with perhaps stencil-printed playing cards or a few sheets of 'domino' or 'damask' wallpaper. Across the way there might be a family from Sweden or Norway and they might have granny's carved and painted chest, or perhaps a rosemarled clock case – shallow carved and painted. There might also be an English family from perhaps Norfolk or Suffolk, and they would have seen the stencil-decorated motifs that are still to be found high up in the roofs of English village churches. The village blacksmith might be Swiss, and he would know all about stencil designing lock plates and window clasps. And

Once a motif has been decided upon, it must be related to a printing registration and repeat grid

The stencil plate is held or positioned with the left hand, while the brush is operated with the right – the brush must be dabbed up and down, not scrubbed from side to side

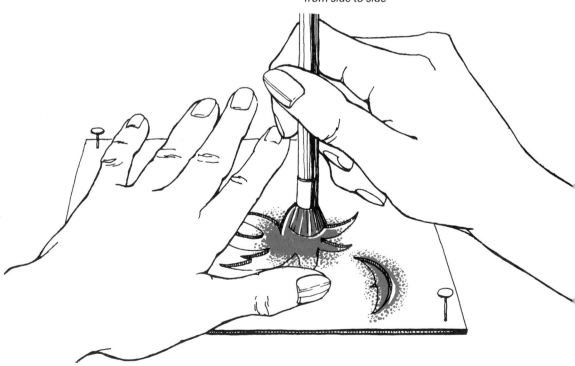

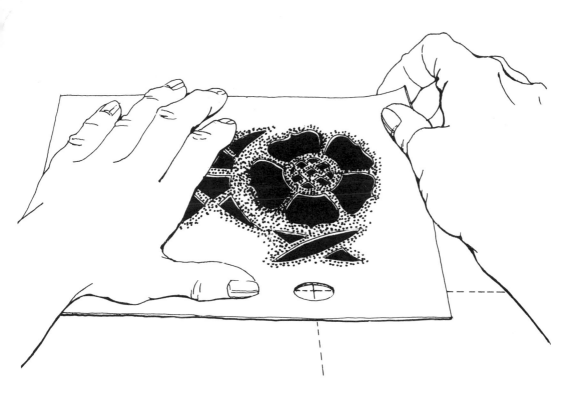

Remove the stencil with great care, maintaining pressure with one hand

Several colours or shades of colour can give depth and a three-dimensional effect

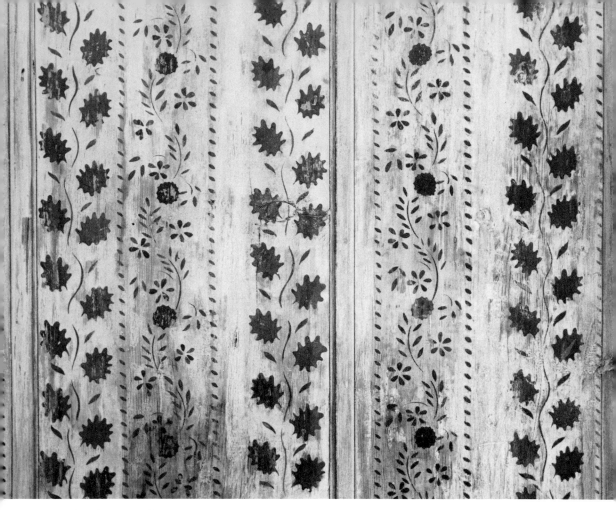

American wood panels which have been stencil
decorated, 1720–1740 (Reproduced by permission
of The American Museum in Britain, Bath)

Furniture fittings of this character would have been
designed by using folded paper patterns, and the
bold 'cut-out' shapes could have inspired stencil
designers and decorators

Drawing of a European wall painting, from early nineteenth century. Compare the individual design elements with some of the American stencil motifs — shells, fountains, trellised garlands, etc

Characteristic American stencil motif, much used on chair splats and panels, and over mantels

so I could continue. Obviously the picture that I am painting is oversimplified, as more often than not the communities tended to be all Dutch, all English, or whatever. The point that I am making is that in a typical colonial community each family would have added small fragments to the grand melting pot of ethnic craft experience.

Let us look more closely at some of the craft traditions.

Domino and Damask Paper

In the late seventeenth century in Europe, paper 'hangings' or 'tapestries' were being printed that were a practical and cheap substitute for costly fabric hangings and drapes. These early wallpapers were sometimes sold in individual sheets or occasionally pasted together and sold in rolls. The important point is that they were printed in bold black line by woodblock and stencil techniques. The papers were described by their makers as 'pretty damasks, marbled, flocks, and india' — sufficient to say that as well as being stuck on the walls and ceilings, they were used to line drawers and boxes. It is possible that the colonialists had a memory of such papers, and more than likely that they possessed perhaps a chest or box that was paper lined. Of course, the French domino papers were originally intended for book decoration, but they also found their way into boxes and chests.

Note: most of the examples we now have survived specifically because they were hidden away in boxes, closets, drawers, etc.

Rosemarling or Flower Painting

Furniture painting and stencilling is a very old craft, and it is thought by art historians that much of it was imitatively inspired by Oriental and Middle Eastern wood inlay. In Europe during the sixteenth, seventeenth and eighteenth centuries it consisted mainly of stencil-decorating furniture and interiors and then building up the designs with rather blunt brush strokes of primary colours. It found expression all over Europe and characteristically the peasant furniture, boxes, benches, beds, etc, were boldly decorated with arabesque and personalised designs. This traditional craft continued well into the late eighteenth century, and nineteenth-century examples are quite common in Norway. In my opinion the best work was achieved in Switzerland, Norway and Rumania.

English Panel Stencilling

In the fifteenth century, English craftsmen copied designs from Flemish and Florentine brocades and transposed them into stencilled

wall decorations. There are several good examples in village churches in Norfolk and Suffolk. In use, the designs were worked directly on wood and plaster panels as regular repeat backgrounds and borders for the more prestigious paintings. It must be supposed that at one time decorations of this character were quite common, but, sorry to say, the examples that are now to be found are hidden away behind beams and high up on roof timbers and screens. English emigrants would have carried at least a memory of these designs to America.

The three crafts which I have briefly described are, I think, the main contributors to the American stencil craft tradition. Enough to say that the craft of stencilling and painting was so widespread in Europe in the seventeenth and eighteenth centuries that there are indisputable links between it and what I have been loosely calling colonial stencilling. Although European and early colonial stencil motifs are similar in structure, by the time the Americans had adopted and taken up the craft, the motifs had taken on a style that was unique.

The motifs in the top row were common medieval-European stencil decorations and the motifs in the bottom row relate to American stencil designs of the eighteenth and nineteenth centuries. Note how they are all organised so that the break or repeat mark becomes part of the total design

Stencil-Decorated Interiors – American

The first settlers lived in log cabins and then, when larger communities were being established, in timber-framed boarded and plastered houses. Domestic buildings of this type were not classically decorated in the European sense – of necessity their style of decoration was related to availability of craftsmen and suitable materials. Decorating with stencil grew and developed over a long period. It must be supposed that at first the motifs were just imitations of the drapes and hangings found in the houses of the wealthy; it must have taken some considerable time for the craft to become structured and organised. The itinerant craftsmen who eventually roamed from state to state stencil decorating houses played a large part in the dissemination of art and craft ideas and styles. A stenciller would arrive in a small village or settlement and for board or keep would decorate whole houses. All he needed were a few brushes, a stock of designs, a few easily obtainable earth colours, some stencil-plate materials – wood, leather or metal – and a plumb bob. Designs and motifs would be suggested by the stenciller and the family he was working for; the range of motifs used was just amazing – leaves, petals, flowers, roses, buds, shells, tassels, swags, bowls of fruit, bells, and eagles – the list is almost endless. Designs were borrowed, exchanged and taken. It was thought at one time that some of these stencillers travelled great distances, but we now think it much more likely that it was the motifs that travelled rather than the men.

At first it was walls and panels that were decorated, but this was gradually extended to floors. Maybe some isolated farmer's wife saw a picture of Eastern rugs and carpets in a catalogue, and this sparked off the idea of floor motifs. Certainly, when one compares some existing stencilled floors with, say, Caucasian rug motifs and Middle Eastern printed silk motifs, there are so many similarities that we must conclude that they drew their inspiration from the same ethnic source. I don't think the colonial stencillers knowingly worked from Old World designs – they must have related subconsciously to previous craft experiences.

Stencil-Decorated Furniture – American

As far as American stencilled furniture is concerned, there are two distinct types; the lacquered furniture, where the stencilling and the application of metallic powders are an integral part of the furniture surface, and the straightforward painted and varnished furniture. With both types the name Lambert Hitchcock is synonymous, even to the extent that most American stencil-decorated chairs

American stencillers collected leaves and placed them between sheets of paper; after some weeks the stain left by each leaf was transferred directly to a stencil plate and then cut

American stencil motif, Henry O. Goodrich (1814–34). A design made of swags, often used for ceiling and door surrounds

are referred to as Hitchcock chairs. With the very expensive 'cabinet pieces' the actual technique of laying down the colours is recorded as follows. First the piece to be decorated was lacquered; then when the lacquer was almost dry precious metallic powders were dribbled and brushed through the stencils on to the lacquer; and finally, the piece was rubbed down and relacquered. The effect is almost of deep inlay work. The cheaper, 'run of the mill' Hitchcock chairs were given a base colour and then grained to imitate more exotic woods; the motifs were then stencilled on with paints and finally the chairs were relacquered.

The craft of stencilling house interiors died out when cheap wallpapers and floor coverings were introduced in the nineteenth century. Furniture stencilling survived in a restrained form into the twentieth century, when it was again taken up by Art Nouveau craftsmen.

Project 7: Stencil Printing on a Pine-panelled Wall

This project is for those who want to decorate a panelled wall surface in the tradition of the early American colonialists. I have in mind a wall which has been battened and panelled with tongued-and-grooved pine-wood. Walls of this character are very common in modern and period houses, and they usually have quite beautiful graining which has, more often than not, been sealed with a varnish. Let us say that the wall to be decorated is situated in the nursery, or infant's bedroom, and that it has been panelled so that the wood strips are vertical. The direction of the panelling isn't critical, but the fact that the wall has a pre-determined vertical grid makes our task that much easier. You must decide very early on in

An American 'Hitchcock' rocker chair, stained, stencil-decorated, and brush-worked and powder-dribbled. Note the graded effect on the leaf motif on the bottom and middle splats (Reproduced by permission of The American Museum in Britain, Bath)

Rocking-chair back-splat design, American, nineteenth century – gilt on black

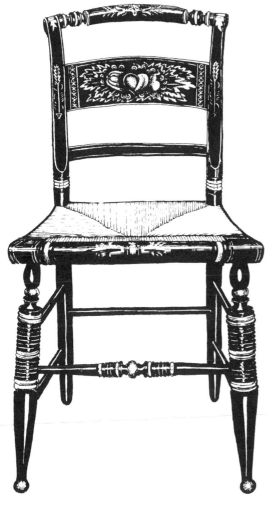

An American, stencilled, 'Hitchcock' side chair. Lambert Hitchcock set up a workshop for the production of machine-made chairs, and over a twenty-five-year period, mass-produced 'quality' and 'everyday' furniture. This particular example would have been lacquered, stencil-worked, brush-worked and then lined with gilt – the colours were made from fine metallic dusts and powders

American 'Fountain' design for a stencil-worked chair back, by Eaton. Note the characteristic eagle, flag and shield motifs

97

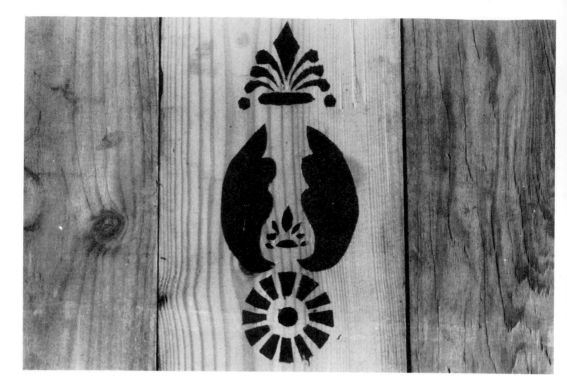

Detail from a rather crude American stencilled panel, which was worked in two colours

Traditional, two-colour willow motif – the outline branches and leaves would each have a separate stencil

this project just how much cutting you are prepared to do and how many colours you want to use. I have illustrated a very simple and basic design, but your choice of picture/pattern subject will obviously be determined by your particular situation and composition preferences. I've chosen chicks – you might prefer tanks, cowboys, rabbits, cars, flowers, or whatever. As most tongued-and-grooved wood comes in widths of 4½in, 5½in and sometimes 9in, it is important that your particular stencil design accounts for this; it is an added problem if the design overlaps the grooves in the wood.

To summarise, we are going to stencil print decorative shapes on a varnished wood-panelled wall. I have chosen to print the motifs in a border or dado that goes around the wall at a height of about 3ft from the floor; this measurement hasn't been chosen at random; it relates to working surfaces, the top of the cot, the window sill, etc. You might prefer to have a border which goes around the wall at almost ceiling level or perhaps climbs around the window- or door-frame; alternatively, you may decide to stencil an overall pattern. This aspect of the project must be given a great deal of consideration.

Choosing the Material for the Stencil Plate
There are several materials that could be used for the plate, so you shouldn't have any

difficulty in obtaining something suitable. Thin, water-resistant stencil card (brown, with an oiled finish) can be obtained from any good artists' supplier, and will do the job, but it does have a tendency to buckle and warp with use. Vinyls, plastics, lino – almost any flat material – can be used, as long as you are able to cut and work it without a great deal of fuss and difficulty. I have chosen to use the very thinnest plywood – it doesn't warp (if it has been sealed), it is cheap and it comes in large sheets. Plywood of this character can sometimes be obtained as scrap from wood merchants – it arrives as packing between sheets of high-quality veneered boarding. Essentially, you are looking for a material that has non-warping characteristics and a high degree of wet strength.

Choosing the Paint

As you are going to stencil on a wall that has been varnished, the most suitable paint is one which dries almost instantly. If a slow-drying household paint is used, there is always the danger that it will run, dribble or bleed. I have chosen to use aerosol car paints and 'Christmas tree' paints (gold and silver), but almost any fast-drying brush-applied paint would be suitable. The advantage of aerosol paints are that they dry almost on contact, they come in a most beautiful range of colours, you don't have the expense of buying and cleaning brushes – all points to be considered.

Designing the Print

Obviously a stencil motif used in this situation must be bold and yet not too complicated; this is not to say that it can be poorly designed and weak. It is vital that the design, as worked in the stencil plate, is made up of isolated holes. I have specifically organised this design so that there is a large area of wood between the holes; if this were not so, the 'linking bridges' of the stencil plate might crumble away as you worked.

Transferring the Master Design

When the design has been fully considered in rough, it can be worked up and then transferred to a good-quality tracing paper. Mark or even label the areas that are to be cut away; this is always worth doing as it ensures that the correct 'windows' of the design are removed. The tracing can then be mounted on the stencil plate with a flour or wallpaper paste. Once the paste is dry, the stencil can be cut. It is important to use a very sharp knife – I personally prefer one of the heavy duty scalpel-type knives. In use, the knife is held in the right hand, rather like a dagger, and guided and drawn towards you with the left hand. Cutting like this, you exert maximum pressure and at the same time have full control of the blade. The cut edges of the plate must fall away at 90° to the surface of the wood; they must not be angled or undercut. Once all the cut edges have been cleaned up and if necessary sanded, the

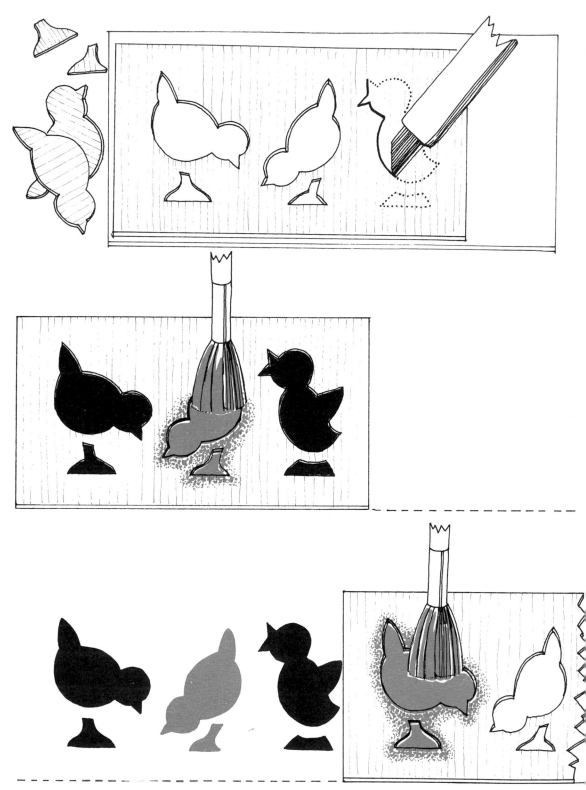

Once the master design has been transferred to the stencil plate, the windows of the design are carefully cut away. The stencil plate is positioned on the base or grid line, and then the colours are applied with a vertical dabbing of the brush. Once the first element of the design is dry, the second colour can be worked

Aerosol paints are ideal for stencilling walls as they dry almost on contact

Art-Nouveau wallpaper frieze on Japanese grass paper, by Shand Kydd Ltd, English, nineteenth century. Block printed and stencil worked in several colours (Victoria and Albert Museum, London)

Art-Nouveau stencil motif taken from a tile design

Wall-dado stencil motif, early twentieth century

Art-Nouveau chair-back stencil motif. Note the very delicate positioning of the stencil plate bridges

plate can be given a swift protective spray with the least expensive of the aerosols.

Registration Marks
As there is almost bound to be a certain amount of paint drift when you operate an aerosol, the stencil plate has to be large enough to protect the adjacent areas of the wall, and will therefore overlap the neighbouring motif. Consequently it is vital that in working you can relate to some form of registration mark. In this case it is relatively simple – the chicks are organised so that they sit on a base line, and are spaced one to each tongued-and-grooved strip. The base line can be drawn out on the wall with a soft pencil.

Printing and Working Method
In working, the stencil plate is taped in position and steadied with the left hand, while the spray container is held and operated with the right hand. Tongued-and-grooved strips are often slightly concave, so it will be necessary to exert slight pressure on the plate to ensure that all parts of the stencil come into contact with the wall. If you are using the brush method, which I have also illustrated, several motifs can be cut in a single plate. With the spray method, each motif obviously has to have a plate of its own, but all this extra effort and expense is offset by the fact that the colours can be graded and merged. Of course before you race ahead and make a total mess of the wall, you should experiment – on the back of the garage door or whatever.

If the technique appeals to you, really composite motifs can be worked by using several stencil overlays.

Project 8: Stencil Decorating a Piece of Furniture

Art Nouveau or New Art is a style or manner of artistic design that was developed in the early part of the twentieth century. It was characterised by swirling natural forms, plant-like tendril motifs and exotic bud-like shapes. The furniture, paintings and architecture of the period seemed to come alive, so powerful were the swollen organic ripplings of the forms. Often, however, aesthetic considerations of line and form so totally dominated functional considerations that pieces of furniture were shaped and decorated in a manner that bore little or no relationship to their purpose. Furniture began to look as if it had evolved, so naturalistic were the forms. To complement this curious and yet very beautiful style, all manner of objects and interiors were surface decorated with powerful plant and animal

A suggested wall frieze design from The Journal of Home Arts and Crafts, *1902 (later called* The House*). Worked in three colours on the wallpaper ground – note the characteristic owl motif*

A 'corner' furniture design, worked in four colours. Motifs such as this were stencil decorated on all types of furniture – trays, tables, side cupboards, doors, etc

Art-Deco lotus motif – common in Lyons tearooms and Odeon cinemas. Worked in three bold colours and gilded

A stencil plate and print for a two-colour dado design

A box or cabinet border of the Art-Deco period. The stencilled stiple effect creates an optical illusion of depth and shadow

related imagery. As only the wealthy could afford the unique handmade furniture, 'everyman' had to make do with rather more ordinary pieces that reflected the style by being painted and patterned. It became fashionable for designers to 'stamp' furniture and interiors with assertive and stylistically positive Art Nouveau motifs and patterns. Many of the popular designs of the period were applied by stencilling; the well-delineated and graphic motifs seemed to be ideally suited to the hard-edged and repetitious technique. The man in the street was encouraged to stencil decorate just about everything in the home – wall dados, table valances, bedspreads, curtains, furniture, etc. I have *The Journal of Home Arts and Crafts,* March 1902 and the September 1909 issue of *The Art Craftsman,* and it is amazing to see just what they considered could be successfully stencilled. I would suggest, however, that you do not bang great obtrusive motifs all over the house, but that you select a motif or two and think carefully where they are to go.

Art-Deco, three-colour, stencilled furniture motif

Idea for a border design

Preparing the Surface for Stencilling
The preparation of the piece of furniture prior to stencilling is most important. If, for example, you are going to decorate a piece that has been treated with wax, or painted, or whatever, this finish has to be removed. I have chosen to decorate the top of a large wooden chest; it was in fact a Victorian clothes box made in pine and covered with many layers of rather scruffy paint, so I first had to strip it and seal it. Once the surface is clean and free from dirt and grease, work can go ahead.

Choosing the Motif
The actual structure and subject of the design must be suitable for the chosen piece of furniture. In my case, as the chest is going against a wall, the design will be viewed from above and three sides. This being so, it can be thought of as a figurative picture, with a top, sides and base, or it can be an asymmetrically free motif. If, for example, you decide to stencil decorate the top of a round table, it would probably be best to choose a symmetrical, circle-based motif – one that could be walked round and appreciated from all sides. After all, a 'duck in full flight' motif in the middle of a coffee table would mean that at least half the people sitting around the table would be seeing an upside-down duck. Once you have considered the many possible relationships between furniture and motif, then stencil designing can begin.

A print taken from a plate of the previous idea – when the plate and the print are placed together there is a curious negative/positive effect. With thought and a bit of redesigning the roles of this particular print and stencil plate can be reversed

Table-top design

105

Design for a large table top. This particular motif comes from The Journal of Home Arts and Crafts, 1902; it was intended for a small inlay table top, but there is no reason why it can't be stencil worked

Cutting the Stencil Plate

This project can be approached in two ways; either it can be considered as a 'one off', in which case the stencil is a 'throw away' and just used the once, or it can be a way of identically decorating several pieces of furniture, in which case the stencil card needs to have a slightly longer working life. As I have chosen to stencil print the top of one special chest, I can use the 'one off' stencil method. (If you want to decorate several pieces of furniture, use the stencil material and method in Project 7.)

The surface of the wood is cleaned as described above. Using masking tape, which can be obtained in most DIY and car maintenance shops, cover the entire surface of the chest. Burnish this whole covering so that it is in contact with the wood. Once the tape has been burnished, the master design can be traced and transferred. In the manner already described, the lines of the design are pencil pressed on to the masking tape surface (see page 85). The next step is rather tricky because it is difficult to remedy a mistake. With great care, all the areas that are to be cut away are inked in and colour labelled. The cutting away of these 'windows' is simple enough if the correct tool is used – I use one of the scalpel craft knives. In working, it is necessary to cut with some sensitivity to avoid cutting into the wood itself. The advantages of using masking tape as the stencil medium are that selected windows can be removed just prior to working with the colour, the colour doesn't bleed under the tape, and the stencil plate is fixed firm.

Choice of Materials and Working Method

As I am stencil printing on an attractively grained wood, I have chosen wood dye colours. These are bright and clear, so the graining of the wood is shown off to good advantage – it is almost as if the wood is being seen through coloured glass. Colourants of this type are

This particular stencil motif is organised so that it repeats from side to side, and it is ideally suited for a frieze or dado design

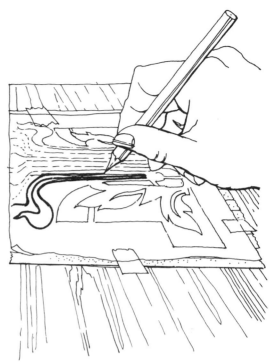

The master design is traced and then pencil pressed onto the masking-tape covering

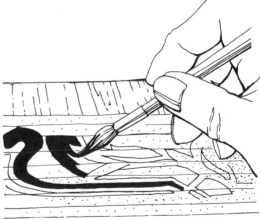

The windows that are to be cut away are marked in with Indian ink. At this stage there is also some room for slight redesigning

Finally, the whole area is spray painted (car spray paint). When the paint is completely dry, the masking tape is removed

107

already mixed with a base varnish, so they don't bleed or run; they can be obtained in most timber shops. In working, you can first remove all the windows that are to be coloured say red and apply the colour, then remove all the green windows and apply the colour, and so on. If this method is followed, there is less danger of damaging and colouring the incorrect areas of the motif. Once all the windows have been cut, removed, coloured and allowed to dry, the remaining masking tape can be carefully peeled away. The result should be a hard, crisp-edged, multicoloured design.

Hints and Tips
If you require colours that are opaque, bright, easy to obtain, fast drying and simple to use, the car spray types are just perfect. It is possible to obtain a stencilled motif that is banded rather like a rainbow. This is achieved by removing all the windows and then spraying in overlapping colour bands across the stencil.

PART IV
WOOD ENGRAVING

WOOD ENGRAVING

Wood engraving is the term used to describe the process of cutting and printing with the end-grain wood. The technique differs from wood cutting in that the block is scratched with various V-section tools rather than being deeply worked with knives and gouges. From the late eighteenth century right up until the end of the nineteenth century, printing with wood-engraved blocks was the primary means of illustrating commercial books, pamphlets and broadsheets; and the process gradually became more and more mechanised.

Thomas Bewick

Born in 1753, Thomas Bewick was the prime mover of eighteenth-century wood engraving. It has been said that he was the first printer to recognise the essential difference between white-line and black-line work; whether this is true or not, his works are certainly amongst the first to be described as wood engravings. With Bewick, the technique of white-line wood engraving is powerfully and beautifully expressed through direct tool marks – his prints are in no way imitative of brush and pen illustrations.

The eldest son of a small-time farmer and mine owner, Bewick was born in the village of Eltringham in Northumberland. His childhood was happy and relatively uneventful, and as a country boy he grew up with a keen love and understanding of all that was rural, spending most of his time bird watching, egg collecting, fishing and helping on the farm. English country life in the late eighteenth century was harsh and cruel; although we now see the period through picture-book imagery as horses, carts, sunshine, harvest time and maidens at work, it was in reality a subsistence living in mud, misuse of animals and hard labour. When Bewick was fourteen, his parents arranged for him to be apprenticed to a printer, R. Beilby of Newcastle. All we know about his apprenticeship years is that whenever he had the chance, 'he ran off into the town and delighted in sketching the picturesque area around the bridge and the river'. When he was free from work Bewick walked to his village and stayed with his parents. As this walk would have taken him at least three hours, it must be supposed that he saw a great deal of the countryside – derelict farms, ruined abbeys and castles, hunters, cottages, birds, beasts and all the wayside plants and flowers.

In 1774 Bewick's seven-year apprenticeship came to an end, and although it was said of him 'still rather limited when it comes to the

A nineteenth-century engraving of Newark Castle. Note the slight crack or join in the block – it appears on the print as a faint white vertical line (Millgate Museum of Folklife, Newark on Trent)

111

Photograph of an engraved block by Charles O'Connor. This is a unique photograph so you will have to excuse the poor lighting and the ink shine. Note the cutaway corners, and the fact that because of the inadequate lighting this block appears almost as a negative – the camera has picked up the raised areas stained with ink

'The Farm Yard', from The Land of Birds by Thomas Bewick. His engravings are characterised by their attention to detail – birds, chickens, even the dead 'warning' herons hung on the barn wall

Engraving from Quadrupeds, published by Bewick in 1790. This particular print is a tailpiece in the technical sense that it comes at the end of a book section; it is also a 'tailpiece' in the joke sense that the little girl is going to trim the horse's tail

'The Swan Goose' by Thomas Bewick. His engraving technique resulted in texture and tone that has been described as 'photographic naturalistic'

drawing of architecture and machinery', he was without doubt an accomplished engraver and an observer of detail. By the end of 1774 he had won a money prize for a huntsmen and hounds print, and he had also worked on some cuts for a book of fables. Like many young men Bewick was a bit restless, and after a few months as a self-employed casual worker or journeyman, he decided that he wanted to see a bit more of the world. His travels took him to Scotland and then London. Although he soon found work, he began to miss the country life and his friends and relations, and after about a year in London he returned to Newcastle. A 'country boy' at heart, Bewick must have decided that he was happiest working in a familiar environment on subjects that related to the naturalist side of his character. Soon after his return, he went into partnership with Beilby, his former printing master. The partnership prospered, Beilby having all the business know-how and Bewick being an accomplished artist and engraver. Bewick's brother, John, was eventually apprenticed and joined the firm, and Bewick worked for the rest of his life in the quiet obscurity of Newcastle.

He is remembered mainly for two books which he illustrated: *A General History of Quadrupeds* and *A History of British Birds*. There has always been some doubt as to who worked the famous blocks, and the matter is further complicated because, at that time, wood

engraving was more or less a group effort in that single blocks would be worked by several people. From what little we know of wood engraving workshops of the late eighteenth and early nineteenth centuries, it is likely that, for many of the prints, Bewick did the designing and the final overworking of the block, while the roughing out of the design and the cutting away of the block ground was left to others.

Woodcuts are worked on the plank grain of the wood, with two cuts of the knife being needed to make a mark, and wood engravings are worked on the end grain of the wood with gravers and scratch tools. Woodcuts, as conceived by let us say Dürer, were worked with knives and gouges with the express intention of leaving in high relief the lines that were to print. Lines in the design were transferred to the block, cut round with a knife and then the whole of the ground or non-printing wood was cut away and lowered; this is referred to as black-line work. With wood engraving, as practised by Bewick, the technique is still relief printing in the sense that the ink is carried on the surface of the wood, but in this case the actual designing and working tools are gravers and cutters. The result of designing and cutting the wood directly is that the white areas around the printing image 'read' as positive, rather than the black.

After Bewick's death in 1828, the Victorians popularised his work. Bewick was a naturalist who loved his craft, and consequently his prints are sincere interpretations of his environment. Unfortunately, because of the Victorians' rather sentimental and moralistic outlook,

Perhaps one of Bewick's most graphic prints, 'The Tiger'. It is unusual in that the white of the printed ground is the result of totally removing the block ground (Victoria and Albert Museum, London)

their reproductions of his engravings are characterised by winter views, robins, holly, garlands, lovers, innocent youth and romantic architectural ruins. This nineteenth-century Bewickian imagery is now served up to us as rather shallow 'Christmas card' prints, but it is still possible to look beyond it to Bewick's early works – technically brilliant, informative and historically enlightening.

This engraving has the title 'Waiting for Death', and was Thomas Bewick's last work. This subject, the old and dying horse, was also the subject of his first recorded illustration (see The Life & Works of Bewick *by D. C. Thompson 1882) (Victoria and Albert Museum, London)*

Wood Engraving Techniques

About 130 years ago, say about 1850, the craft of wood engraving was at its peak – hardly a book, poster or shop window advertisement appeared without some sort of engraved illustration. It has been said that engraving wood is really a carving craft and that without the efforts of the printer the engraver's work would not be visible; strictly speaking this is true. The craft was split into several distinct areas – artists worked the designs, engravers cut the blocks and printers took impressions. Engraving the wood was a means to an end, not the end in itself.

By the middle of the 1880s the craft of

printing had reached a technological cross-roads; for the first time, the printer was able to choose between two distinct illustrative techniques. If he wanted a swift, fine line illustration, he used a steel-plate engraving, and if he wanted masses of dark tone he used engraved wooden blocks. For the wood engraver this situation was further aggravated by the invention of a fast, photographic, steel etching process. Trying desperately to compete, the wood engraver worked to order, and made as many procedures as mechanical as possible. What had once been a leisured reproductive craft, became sweat-shop labour. In *The Girls Own Paper* of March 1886 there is an evocative article by Richard Taylor entitled, 'Wood Engraving As An Employment For Girls'. The description is so telling that I am quoting the article as it stands.

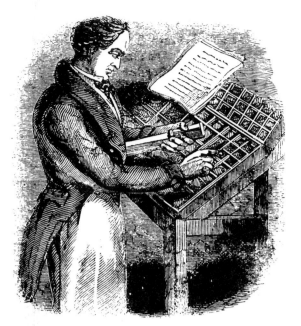

'Days at the Factories'. This engraving by Dodd shows a compositor, who places the print in frames ready for printing (Victoria and Albert Museum, London)

If you have ever experimented with your knife, you may have noticed that it is easier to cut in one direction of the grain of the wood than another, and that the lines formed by cuts across the grain were likely to chip out and break; this would never do for the engraver. He must be able to make firm lines in any direction, so that the wood for his purpose is cut endways of the grain. The tree trunk is sawn into slices about an inch thick not lengthwise like a plank. The wood must be hard too, or the thin lines will not stand the pressure of the printing press; and although mahogany, pear, holly, etc will do for the common work, such as for very bold advertisements, bills and the large pictures pasted on walls, box is the only wood yet found to answer all the requirements, and yet even that has to be well selected. Soft, red, or brittle wood is the engraver's bête noire [hateful object] while the pleasure he feels in engraving on a block formed of hard, fine grained wood of pale, yellow colour is akin to that which an alderman is supposed to experience when eating turtle. The tools cut without effort, and the lines are free and clear. As the diameter of the box tree is small, and the 'slices' or 'rounds', as the blockmaker calls them, will seldom finish a block as large as four or five inches square, it is necessary to glue and

fasten pieces together by inserting what carpenters call a tongue. For a large cut it is obvious that only one engraver at a time could be engaged, and apart from the inconvenience of working on a very large piece of wood, it might take so long to execute that, in the case of subjects of passing interest, the event he had to illustrate would be forgotten before the block was out of his hands. These 'amalgamated' pieces are therefore formed into still larger blocks, that can be taken apart, engraved and afterwards reunited by putting a brass bolt with a screw at each end, through holes in the sides of pieces intended to be joined, screwing nuts on each end of the bolt, and thus screwing the pieces of wood closely together. The blocks are planed to a smooth polished surface. Great care is taken that the wood is well seasoned, or each piece may warp and twist, or separate from its fellow, but in spite of all, sometimes the joins will open and appear as white lines across the print. Blocks should be kept in as even a temperature as possible, stood on their edge when not in use, that air may circulate equally on each side of them, and wetted as little as possible. When laying the ground [painting the block white] the back of the block should also be slightly dampened, that both that and the face may swell equally otherwise the wood may warp. The tools are few and inexpensive and are named more from the uses to which they are put than from any great difference of form between them. The graver may be taken as the typical form and with the several sizes everything that can be done on the wood can be executed. Being broader at the back than at the belly, a little more or less pressure will enable you to produce an open cut or a fine one at will, but where the object is to engrave a series of parallel lines, or a tint, with mechanical evenness, this is not an advantage, as a slight unintentional pressure might defeat the object in view, so a tool a little narrower at the back than the graver, and called a 'tint tool', is used. The tools are fitted to cut lines of different widths by rubbing the 'belly' of each on an oilstone till it is broad like the back of a penknife, instead of being, as when purchased, sharp like its edge. The scooper, or scauper, as it is called, is narrower at the back than the tint tool, and is besides, broader on the belly, without being made so by the engraver. It is

A typical magazine engraving dated 1885, showing the front of Beauvais Cathedral. The engraved style is characteristically Victorian – heavy, dramatic and imitative of pen and ink work

Photograph by Paul Martin (1885–1900), 'Engravers at Work'. There are four sets of tools, and the engraver on the left is just a child. (My own great-grandfather was an engraver in East London; he had to work long hours, he had to work fast, and if he failed to please there was always someone ready to take his place) (Victoria and Albert Museum, London)

An illustration from The Girls Own Paper, 1886, from an article entitled 'Wood Engraving As An Employment For Girls'. Note the globe of water or light concentrator. This picture illustrates the girl or young lady of the pre-typist era. As employment, engraving was better than going into service, but it was still an occupation reserved for the poor, lower middle-class

A print taken from a piece of rough-sawn, end-grain wood. The actual process of preparing the wood for engraving is so demanding that the materials are best obtained from a supplier (addresses at the end of the book)

Engraving from The Girls Own Paper, *1886. There is no doubt that magazine engravers knew the craft inside out; they used every possible tool texture and explored all types of text and illustration arrangement*

used for scooping or clearing out large white places, or non-printing ground. The principal things actually required by the engraver are, a magnifying glass, such as watch makers use to look at fine work, a small chisel or 'flat tool' to lower the extremities of the lines as they go into the white, a leathern cushion, about six or seven inches in diameter, filled with sand (to make it heavy) to rest his block upon, and to enable him to turn it freely round, and an oilstone to sharpen his tools upon.

The mode of holding the tool is not always the same. When working near the extremities of a block, the thumb is placed so that it is pressing against the edge, and allowing the hand to move the tool backwards and forwards. When the parts to be engraved are too far to be reached in this way, the thumb is placed on the surface of the block, and pressed on to it, so as to form a stay for the hand when moving the graver about. It is scarcely necessary to say that a good light is essential, and that in the foggy,

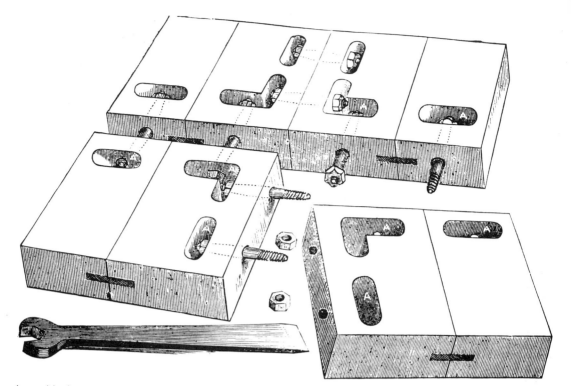

Large blocks were made by bolting together smaller units – this engraving shows how the block clamping was organised. The blocks were also tongued-and-grooved to resist warping

An engraving tool: the face is the cutting end, which determines the depth and width of a cut; the back is the top which forms a rest for the thumb; the belly is the lower edge of the tool

Engraving tools, their faces and cutting edges drawn below each one: (left to right) graver, round scorper or scauper, spitsticker, tint tool, square scorper or scauper, mechanical or multiple tint tool, ground or chisel tool

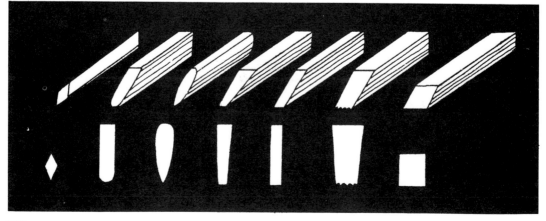

dark days of an English winter, when an engraver for weeks at a time is compelled to use an artificial substitute for daylight, the strain on the sight is very great. The best gas burner, even with an opal reflector over it, will not enable him properly to see his work. So he places in front of his light a glass globe filled with water [sometimes coloured green with a few drops of nitrate of copper] which focuses or concentrates the light on to his block. By this contrivance a clear bright light is obtainable, and one burner placed on a round table will suffice for five or six persons. A bullseye, such as policemen have in their lanterns, will answer the purpose as far as light is concerned, but it does not protect the face and head from the heat of the gas so well as the globe. If the engraver slips, makes a mistake, or his work becomes accidentally injured, the defect can only be corrected, more or less imperfectly, by inserting another piece of wood and re-engraving on that. This he calls plugging. The part to be altered is cut away, and a hole made nearly through the block with a gimlet or drill, a piece of wood is cut to the required size, dipped in glue, and inserted in the hole, and driven firmly home with a hammer. As it stands a great deal above the surrounding surface, much care is required to saw off and smooth the plug down level with it. If the work be delicate, plugs are seldom a success, the adjacent lines are nearly sure to be bruised or pushed out of their place; sometimes too the plug itself will sink or come out. Before a design can be engraved it has to be drawn on the wood. This was done by the engraver himself, now it is a distinct profession; an unfortunate separation, though for commercial reasons inevitable. The blocks being planed to so smooth a surface, it is necessary before attempting to draw on one to lay some kind of ground to

Marks and print textures: (left) The graver is, for me, the main tool. It is capable of tremendous textural depth; (centre) The tint tool cuts the stripes of all sizes, types and designs. As the width of cut broadens, so the effect is of increased light. The white patches are created by the use of the coarse spitsticker; (right) Multiple rake-like tools give an even, spaced finish, but this can also be achieved by using the graver. The light areas of the print represent areas of greater and more compact cut

afford a hold to the pencil which otherwise will slip about. For this purpose, some draughtsmen lay on a thin coating of Chinese white with a large brush; others, a prepared white, procurable at the artists colourmen's. And many take simply a little flake white or zinc white in powder, and put it on the block with a small pinch of finely powdered bath brick and a drop or two of water, into which a little gum arabic has been dissolved, spreading it with the fingers as evenly as possible, and then allowing it to dry for a few seconds, then with the ball of the thumb rubbing off any loose. The design is usually first made on paper, and more or less finished according to the skill or preference of the artist, and varies from the roughest scrawl, making only the disposition of the figures etc, to a nearly completed drawing, where the light and shade and everything but the smallest details are carefully delineated. A piece of tracing paper, a little larger than the block on to which the drawing is to be transferred is then placed over the drawing, and a tracing made of it; and in cases where only a slight sketch has been made, defects in drawing corrected. A piece of red or black transfer paper is now placed on the surface of the prepared wood, and the tracing [reversed] on top of that, and firmly secured to the block either with a little gum being

An engraved print of a pony trap, probably for a trade paper or advertisement. The large area of black represents the ground area that has yet to be cut – obviously the Victorian engraver who was working on this block was called away and never finished his task (Millgate Museum of Folklife, Newark on Trent)

put along the sides, or by rubbing them with beeswax and pressing the overlapping margin of the tracing firmly upon them. The traced design is then gone over lightly with a hard pencil and still further corrected and additions made to the drawing. Assuming the design to be drawn on the wood in one of the ways described, the engraver's first care, when it reaches his hands, is to protect it from accidental erasure during the time he is engaged upon it, the moisture from the hand or breath being sufficient in a short time to obliterate the pencil marks or blur the tones, if precaution be not taken. This he does in much the same way as the artist fastens his tracing to the block [as already described] that is with beeswax. A piece of paper is pressed over the entire surface of the waxed block, a small hole is torn in this paper, and the part on which he begins to work is thus exposed to view. As he works, he gradually enlarges this hole until the entire piece of paper is torn away, when, the engraving completed, the necessity for protecting the drawing no longer exists. In fact, there is no drawing needing protection; but in its place are the incisions which the engraving tools have made.

Once the block has been cut, the next step is to get a trial proof, an impression made sufficiently good for the engraver to see what corrections, if any, are needed. For this purpose, and for small work, a dabber, a pad

A Victorian romantic engraving dated 1883, from the story A Tale of Rome in the Golden Age. *It is beautifully worked with adventurous use of cross-hatched lines for the flesh and cloth tones*

of wool and horse hair covered with strong fine silk, is best, but for large work, a roller such as printers use, is the most suitable. Printing ink is spread with a palette knife on a smooth surface, generally a piece of marble, iron or glass, and worked with the roller or dabber until quite fine and evenly distributed. The block is then carefully cleaned with India rubber to remove any greasiness that the engraver's hands may have left on it, and the roller passed over it a few times, backwards and forwards, until sufficient ink adheres to its surface to yield a black impression. A piece of India paper is then laid on the block, and the paper rubbed at the back with a steel burnisher or ivory knife, until the ink sets off on to it. In order to see what progress he is making where lines are sufficiently printed, or where more rubbing is required, the operator will from time to time lift a corner of the paper and bend it back so that he can see the surface, keeping all the while the left hand firmly pressed upon the block, so that the paper may not shift and a blurred or double impression be the result. Proof taking is a delicate operation, requiring taste, practice and care. Few engravers excel at it, the efforts of some even skilful engravers being absurd. If too much ink be used, or if it not be

'The Taking of Alice Lisle', an engraving (after a painting by E. M. Ward RA) from The Leisure Hour, a family journal of instruction and recreation, 21 October 1876. (Alice Lisle was executed for treason during the reign of James II.) Engravings of this character were made to look as if they had been drawn with pen and ink, so there is hardly any white cross-hatching; the black hatching is in fact created by the systematic removal of lozenge-shaped nicks of block wood

worked about enough before being put on the block, it will get into the fine cuts and fill them up. If the burnisher be used with too heavy a hand, the thin lines will be irremediably injured. To guard, therefore, against such a casualty, the proof taker usually interposes a thin piece of card between it and the paper, rubbing on that, and only touching the paper with the burnisher to bring up the strongest darks.

To conclude, supposing that a girl be willing to make the indispensable sacrifices and be determined to become an engraver, it is still most difficult to say how she had best proceed. In an office an apprentice usually pays a fee of £30, for a term of not less than five years, and this sum, with an additional £50 or £60 is returned to him during the term in the form of a weekly wage, none being paid during the first year. But as far as I know there is no office at present open to ladies. Perhaps she may be able to find some male engraver who would take her as an apprentice. Much of the work in London is done by engravers working by themselves in their own homes, and there be fewer objections to her working with one of these in the house with his family, than her doing so with him in an office in the city.

The engravers tried desperately to compete with chemical processes; they devised ingenious methods of locking together dozens of blocks on which there was a photo-graphically reproduced design.

This done, the pieces were taken apart, and each piece given to a different engraver and if he be careful to follow closely the work commenced on the margins, the pieces when reunited will appear as if engraved by one person. In this way the large blocks filled two pages or more of the 'London Illustrated News' or the 'Graphic', and divided up to thirty six pieces, may be executed by as many different engravers in a few hours.

The wood engraver had become a night worker, a small cog in a large wheel; he was even trained so that his work was indistinguishable from that of his fellows. Inevitably, by the end of the nineteenth century commercial journalistic engraving had fallen into disuse.

'England, Scotland and Ireland' – a romantic Victorian engraving dated about 1860, after a painting by C. Baxter. Magazine engravings of this character had to be sharp in texture and rather obvious in subject matter

SPRING STRIFE.

Now the warriors of the air
 Rise in wrath and arm for wars,
For the earth no bloom doth bear
 Where they scattered dust o' stars.
Bright young Wind, with streaming hair,
Marshals them as forth they fare.

Spring's young warriors, fiercely fain
 For the fine of such dread dearth,
Cast their crystal spears of rain
 Passionate upon the earth,
Crying "Tyrant! loose thy chain,
Yield our stars o' Heaven again!"

Cried a voice, in its grimly mirth,
 "Vain this fume! The horrid worm
 Grips them deep within the earth,
 Where the dust and rust trans-
 form
 Even star-dust's golden worth,
 Choke the seed that
 breaks for
 birth!"

All those myriad germs of life,
 'Mid the death and darkness, heard
In their dreams the shining strife,
 Tried to ope their eyes, and stirred;
Earth's wide breast with pain was rife
As each pricked with tender knife.

Each blind bladelet must upward creep
 T'wards the sound of tapping shower,
Push and pant, then pierce, and peep,
 Half afraid, a tiny flower,
While the year's young sun doth keep
Golden guard o'er golden sheep.

Primrose, daffodil, crocus brave
 (These, those golden creatures' names)
Break, like fire from out a grave,
 Stars and golden cups and flames.
Then, lest Winter, sorry knave,
Harm these innocents, and rave,

That bright Shepherd hath bounden him
 In a golden-chainèd thrall;
Children, glad as cherubim,
 Greet the flowers, first and small,
While pure sprites whose eyes were dim,
Wipe the tears, and 'gin to hymn.

<div align="right">M. E. HINE.</div>

A newspaper heading for the racing page, dated
about 1849. This particular print was taken from a
metal composition block, which in turn was a copy
of an earlier engraved woodblock (Millgate
Museum of Folklife, Newark on Trent)

Victorian magazine engraving with inset text —
romantic subjects were the vogue in the middle
Victorian period. The ferns and flowers are beauti-
fully observed. Illustrations of this type were
frequently cut out, mounted, framed, and hung over
the bed

This wood engraving illustrates Ridge & Co the
printers — they printed Lord Byron's first poem,
'Hours of Idleness', in 1808, when he was a student
at Cambridge (Millgate Museum of Folklife, Newark
on Trent)

An early engraved cartoon – perhaps the disarray of the coat of arms and the supporting lion and unicorn relates to some, now forgotten, royal rift. The block has a deep scratch across its surface which prints as a white line (Millgate Museum of Folklife, Newark on Trent)

Project 9: Engraving a Bookplate

A bookplate is a decorative label with a name or device, pasted in the front of a book to show ownership. In England and Europe there is a long tradition of such family and personal labels; no doubt the idea must have its roots in the past when books were rare and expensive. There is something rather pleasant and touching about opening an old book and finding a print which gives the name and address of a past owner. Sometimes this information is written in by hand, but more often than not it is worked into the design. Our task or project is to design and print a number of these plates. I have chosen a motif that is Art Nouveau in style; it was inspired by a piece of very late nineteenth-century repoussé work. I personally find looking at period objects a good starting point for designing my printing work. This particular design or plate contains a worked monogram and a space for, say, the name and address. A word of warning: if you intend to incorporate a set of initials or numbers in the design, don't forget that they have to be cut on the block in reverse.

It is quite possible for this project to be accomplished with just a single tool, the lozenge-shaped graver. If, however, you wish to experiment with another tool, then I suggest that you obtain a medium fine spitsticker, which can be used for cutting curved lines and pecked texture. Although wood engravings are best characterised by the fineness of the cuts and the delicacy of the printed lines, you should at first concentrate on coming to a clear understanding of the working methods; you can aim for very fine line work when you appreciate all the pitfalls. In this instance, you will be required to cut curved and tapered lines, pecked dots and a straight border. As this particular motif is circle based, symmetrical and well balanced, it is important that you are able to use the tools with some confidence; to this end the design has to be well organised and tool and skill related. Engraving calls for a great deal of steady line work and minute detail, so it is a good idea if you practise tool control on a bit of waste wood – mistakes can be difficult and expensive to remedy.

Transferring the Master Design to the Block
Once you have fully considered the size and period of the design, etc, it is time to transfer it to the working face of the block. Some engravers are quite happy to pencil draw in black line directly on the whitened face of the

Drawing of a design by William Faithorne, 1668. Designs of this character make ideal bookplates – a ribbon for a motto and a shield for the name, etc

128

Idea for a bookplate design. Initials and other details can be either engraved in the shield, or written in by hand when the plate has been printed

English bookplate design from the 1920s, 'Swallows flying east', a characteristic design of that period

block, but I prefer to use a tracing of the master design. The method isn't difficult, but you must remember that in this instance it is the black areas that you will be cutting away, not the white. A small amount of white gouache or Chinese white paint is smeared over and into the face of the block to provide an even, matt, working surface. I must repeat that this method of working is contrary to woodcut practice because the white of the block will actually print as black, and the black as white; but as the design in this particular instance is intended just to print flat black and white and is without tone, it is permissible. When the white paint is dry, the traced design is pencil pressed directly on to the matt surface. The transferred design can then be lined in with a soft pencil; if the dry paint 'ploughs' up in front of the pencil point it means that it was applied too thickly. The areas to be cut away are blacked in with the pencil.

Cutting the Block
The block is held firmly in the left hand and supported on top of or against the side of a sand bag; the actual angle of support and the precise handholds are entirely up to you. The graver tool is held and worked with the right hand; it should not be dug or stabbed into the wood, but worked in a scooping motion. It is most important that the tool is sharp, for if it is blunt it is liable to skid out of control across the block. In working, the wooden handle is nestled in the palm so that the full weight of the arm is behind the cutting thrust. The right hand pushes and guides the tool, while the left hand supports and turns the block. It is really a simple process of continually manipulating the block so that the line of the next cut is directly in front of the graver. The relationship between the depth and width of the cut line should be continuously watched – the deeper the cut of the tool, the wider the groove that will appear as a white line on the print. (Note: the printing relief surface of the block should not be undercut; the printing surface should fall away as a bevelled slope until it meets the cut-away ground.)

With the design illustrated it isn't necessary for the tool marks to be expressive; all you have to do is guide and work the tool in a manner that is precise and efficient. A little tip: the leaf-like areas of the design are achieved by cutting the tool in and then slipping the tool out; this movement gives the little 'quiff' cuts that are so effective.

Always have at hand a piece of old block to test the cutting edge of the tools, and also a flat oilstone and a few slips so that if the tools are blunt you will be able to resharpen them. In practice, if a cutting tool doesn't immediately bite into the wood, then it needs sharpening.

In this particular instance, the area of the block that is to be worked is painted black and then cut away, so in effect the white design area of the block prints as black. If you include initials or letters, they must be cut on the block in reverse

This illustration shows what is generally considered to be the incorrect hand hold — that is with the fingers wrapped around the tool shaft. Although there are as many ways of holding the engraving tool as there are engravers, it is usually held in the right hand, with the 'belly' away from the palm

Printing

Once you have obtained a suitable paper, say an Indian or Japanese fine tissue, and a tube of black printer's ink, then you are ready to print. A small amount of the ink is squeezed from the tube on to a sheet of plate glass, and then it is rolled backwards and forwards and from side to side until there is an even film or smear of ink on both the roller and the glass. If the paper to be printed is about the size of a post card, there is no need to cover the entire sheet of glass with ink – just sufficient for the job is my rule of thumb. The inked roller is worked backwards and forwards across the block until the relief surface is evenly covered; the roller is then placed out of the way – on its back to ensure that it doesn't roll about and also that its surface doesn't come under too much damaging pressure. Next, with a straightforward, swift movement, the paper to be printed is placed on the inked surface of the block. A piece of card is placed on the paper, and then the whole is rubbed or burnished with the back of a comb, the handle of an old toothbrush, the dish of a teaspoon, or whatever. You can lift one corner of the printing paper during this operation and see if the ink is evenly distributed. Finally, when you are happy with the results, the paper

The correct way of holding the tool. The wooden handle is nestled in the palm, flat side down; the middle fingers guide and support the shaft; the thumb supplies the angle of cut and the pressure

The block is supported and manipulated with the left hand, while the cutting tool is held and guided with the right hand. The cutting action is one of controlled pressure – the tool must not be allowed to skid and dig

is lifted by one corner and, with a single deft movement, peeled off. Don't drag the paper about, or try to take it off and then replace it; this is bound to result in a smudged mess. If you aren't happy with a print, throw it away and have another go.

There are all sorts of things that can go wrong: the paper can be so thick that it soaks up the ink, or it can be so thin that it tears; the ink can be so thin that it runs into the cuts of the block, or it can be so thick that when its treacly mass is sandwiched between paper and block the result is a sort of uncontrollable inky 'cream slice' – not a pleasant sight. The answer to all of these problems is to experiment, observe and readapt the technique or try an alternative material.

Note: after printing, the block must be thoroughly cleaned with turps and then allowed to dry naturally away from a direct source of heat.

Eric Gill

Eric Gill was a sculptor, wood engraver and typographical designer. Since his death he has been described as one of the leaders of the twentieth-century craft revivalists, and perhaps the most influential Western wood engraver of modern times. The work of Gill the artist can be better appreciated when Gill the man is placed in a historical context.

Born in Brighton in 1882, Eric Gill was the son of an Independent Church minister. By the time he was about seventeen, he was already showing considerable artistic promise; it is on record that he was interested in drawing and architecture. When the Gill family moved to Chichester he wasn't sorry to leave Brighton, which he later described as 'a slum with a Regency façade'. He thought that Roman-built Chichester, on the other hand, was a beautiful city – environmentally and artistically ordered. In many of Gill's early sculptures there is considerable evidence that he was greatly influenced by the Romanesque bas-reliefs in Chichester Cathedral. Although his relationship with his father wasn't all that it perhaps should have been, his father appreciated his talents enough to send him to the local art school.

By the time Gill was in his early twenties he was working for a London architect, but although he was by all accounts an able designer, he was emotionally out of tune with current architectural thinking. At that period, buildings were still required to be 'Victorian' in that they had to be heavy with decoration and ornamentation; Gill was interested in design that was functional. He gradually became less interested in architectural theory, and more interested in the craft practice of working with stone. He spent most of his time studying letter cutting and typography at the then new Central School of Art. Under the influence of his teacher, Edward Johnson, Gill developed a style and manner of working that was tidy,

Eric Gill print, 'The Juice of My Pomegranate' – proof of an illustration from Song of Songs. *A beautifully designed work, with not a cut or line wasted* (Victoria and Albert Museum, London)

133

efficient and idealistic. Teacher and student were so artistically and intellectually compatible that they formed a friendship that was to last a lifetime.

By 1904 Gill had married Ethel Moore and was earning a small income, lettering boards for W. H. Smith, cutting tombstone inscriptions and working on book designs. Over the next few years he gradually built up his contacts until he was obtaining a steady flow of sculptural commissions. Although many of these were small and not very exciting, they enabled Gill to develop his craft style and confidence. He was always religious and he resolved to bring together his religious and craft beliefs. Consequently, he set up home and workshop in the small Sussex village of Ditchling in 1907. Gill rejected establishment art and also the great artistic and moralistic movements that were set up at the end of the nineteenth century; but these attitudes apart, he was such a charismatic person that a group of artists and craftsmen gathered around him. The religious and artistic community that resulted was considered by the world at large to be 'odd', 'cranky' and maybe just a little dangerous.

By 1920, Gill had become a Catholic convert and Dominican tertiary; he tried in all his daily activities to live out his religious, social and artistic beliefs. He believed passionately that man's love for God, man's sexuality and man's artistic creativity were all parts of an identical wholeness. He was very definite about his views, and he didn't do things by halves – he wore monk's clothing, ate only natural foods and concentrated on sculptures that were overtly religious and sexual. A visitor to the Ditchling community said, 'water froze in the wash basins, bread and butter were homemade, and eaten off wooden plates, the only lighting was candlelight, and the members of the family were mostly dressed in clothes that had been hand spun and hand woven.' The community soon became something of an artists' meeting place, and Gill was befriended by Augustus John, Roger Fry, Epstein and others. This popular acclaim grew and the number of visitors increased to such an extent that Gill came to the conclusion that he would have to move to a more isolated setting.

During this period, Johnson (Gill's teacher), a friend who was a printer and several others were all living at Ditchling, the idea being that they should work as individuals and contribute to the community. Gill was, by this time, a well-established sculptor in wood and stone, but he was also experimenting with woodblock

'Approaching Dawn' – an Eric Gill print for an edition of Chaucer's Troilus and Giseyde, *1927*

printing – he was continually searching for new methods of artistic expression. His work of the pre-1924 period has been variously described as dynamic, primitive and so highly charged with religious and sexual symbolism that it bordered on the pornographic. Obviously, many religious critics of the period were disturbed, some even to the extent of wanting him restrained. This adverse criticism, and Gill's desire for isolation, resulted in him moving home and workshop in 1924 to a semi-derelict monastery in the village of Capel-y-ffin in central Wales.

Gill's time in Wales was most productive as far as wood engraving was concerned, and although the art-buying public were often disturbed by the subject matter of his work and the thinking that lay behind it, his limited-edition books were a fantastic success. It must be remembered that at this period the craft of printing with woodblocks was being relearnt and, linked with this, private printing presses were producing in-vogue art works. Gill's particular style or manner of design was characterised by heavy, clean, black and white imagery. In working, he cut away the wood in the 'woodcut' tradition – the high-relief wood that remained was intended to convey the message, rather like Japanese woodblock prints. The result of his method was not the textural, naturalistic, white-line technique that we associate with let us say Bewick, but bold, flat, graphic areas of black and white. Gill worked for the Golden Cockerel Press, producing what is, perhaps, the wood-engraved work for which he is best known. He was happy enough in Wales, but he gradually felt that he was, as far as commissions and communications were concerned, too far away from the centre of things, and in 1928 the Gill family moved to a village just outside High Wycombe.

In 1940 Gill died of lung cancer, and if accounts of his last moments are anything to go by, he must have been a totally fulfilled person. All through his life his artistic ideals were powerfully felt and expressed, and in no way did he 'bend' or adjust what many considered to be an uncompromising style. The inspirational roots of his attitudes towards woodblock printing style and method are rather difficult to analyse; however, as he was trained as a letter cutter and worker of stone, it must be supposed that this was a major influence. He was always concerned with the total page, never with a single illustration, even to the extent that he thought it necessary to design two new typefaces, Perpetua and Gill Sans. Gill treated each page of the book as a piece of art work in its own right; everything had to harmonise – the illustrations, the type and the blank spaces had

to be perfectly balanced in tone and structure.

It has been said that Gill and his work more rightly belonged to the medieval tradition, but although he was perhaps out of step with the society in which he worked, he is now seen (against a backcloth of post-World War I anti-industrialism) as an artist of his times. His work is without doubt ingenious, powerful, true to the period in which he worked, inspirational and above all sincere.

Project 10: Engraving a Christmas Card

This project is designed for those who wish to print a batch of personalised Christmas cards in the style and manner of the twentieth-century engravers. Before you start, however, it is important to have some understanding of the period and the artistic context in which these engravers worked.

It is generally accepted that wood engraving, as far as we are concerned, first found expression in the late eighteenth and early nineteenth centuries. Thomas Bewick lifted the craft out of the heavy, rather lumpy, black-line tradition and explored the exciting possibilities of working directly with white lines or, as it has sometimes been described, 'letting in the light'. By the time of Bewick's death in 1828, the white-line aspects of engraving were well understood and, on the whole, practised with real feeling and sincerity. However, during the nineteenth century newspapers, journals and advertisers increasingly used it as a swift, clear, cheap way of getting their message across. By the end of the nineteenth century engraving had become a mechanised function; artists were replaced by a photographic process and block cutters were employed to work to order. The cutters were no longer asked to be sensitive interpreters, they were just required to dig out the wood in a fast, impersonal, conforming and swift manner. By about 1900 the photographic line block process had taken over completely. Fortunately, at this same period the Arts and Crafts Movement, and such individuals as William Morris and Charles Rickets, inspired by medieval illuminated manuscripts and block books, took a new interest in printing with wood blocks. Gradually a great world-wide revival of interest in all forms of handcrafts got under-way, and by the middle of the 1920s a number of studio workshops and private presses had come into being. These 'new wave' artist/craftsmen saw the old neglected crafts as a medium for personalised artistic expression. Of course, like the Pre-Raphaelites and others before them, the revivalists had to relate

A Charles O'Connor print called 'Toadstools', traditionally concerned with naturalistic texture and form

'Snowdrop', a limited edition print by Charles O'Connor, with cross-hatched white line on the petals

136

'Fir Cones', a print by Charles O'Connor. The design uses as much of the block area as possible

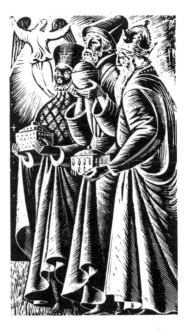

Eric Fraser – headings for the Christmas edition of the Radio Times in 1950. It was work of this character that set the pace for the Radio Times illustrations of the sixties and seventies. Although much of it is now worked on scraper-board and then photographed, it is still related to, and has its roots in, earlier illustrations (Victoria and Albert Museum, London)

137

Christmas card design, from a middle-European early nineteenth-century silhouette motif

continually to earlier traditions. It must be remembered that many of these craftsmen were disenchanted by World War I and with factory mass-production, and the work of this period has been described as 'stark, raw, bold, direct, uncompromising, aesthetic, non-commercial and above all anti-establishment'. Although now we might have difficulty appreciating the subject matter of these prints, at least the techniques are direct and easily understood. With these new engravers there was the feeling that pen and pencil work had been imitated for long enough, and it was now time for the craft to be self-assertive and free from deception. In a few words, direct white lines cut in black were considered to be more honest and expressive than lines cut so that the resultant print appeared to be drawn or brush worked.

Preparing the Design
We are going to print a straightforward white-line design, one which can be cut directly with a graver, so it is vital that you don't get caught up with pens and pencils in the design stages. The best way of designing an engraving of this nature is to use brush-applied white ink on

Christmas card design taken from a European church window dated 1350

Idea for a Christmas card — simple to cut, direct design subject (this work was done by a student)

138

A rare photograph of one of Charles O'Connor's woodblocks. As the block was cracked rather badly, prints had to be taken with care and then touched up

Charles O'Connor print, 'Long-Tailed Field Mouse', taken from the block shown in the photograph above. This is the actual size of the block and print

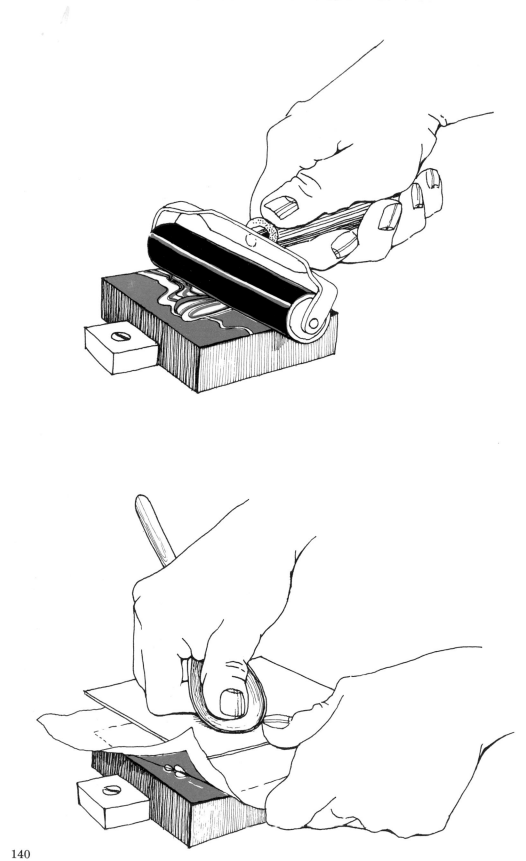

black paper – after all, the end product will be black printed ground with a white cut design. An alternative is to use black scraper-board; this black-coated card reveals a white under-surface when scratched or cut, and the result is almost indistinguishable (at a glance) from a print. As I am assuming that you are new to engraving, the design for the Christmas card has to be basic, but this is not to say that it can't be well thought out. The subject matter has to relate to Christmas, so you have the choice of angels, the crib, Jesus, stars, holly, winter, etc. Try to work within the limits of your craft ability; you might have a desire to 'capture the true and inspirational vision of the first Christmas', but if this involves a vast amount of difficult-to-cut symbolism and textural metaphor, then perhaps you had better reconsider.

Preparing the Block
If you feel confident, you can start cutting the block with almost no preliminary design work, but as mistakes are expensive in time and materials, it might be as well if the block layout is fully considered and planned. You must always keep referring to the fact that the design is white cut out of black. With this in mind, it is sometimes a good idea to blacken the block prior to working, then each cut will appear as a lightish mark. The surface of the block should be brushed with a dark water-based ink – don't saturate the wood as this may result in a distorted printing surface. When the ink is dry, the master design can be traced and pencil pressed on to the block; the lines of the design should appear as faint silver-grey marks. In cutting, these marks would very soon become smudged and blurred, so it is as well to spray the block with a fixative. (Sprays of this type can be purchased from most art suppliers.)

(Note: as a general rule, it is advisable to treat the back of the block in much the same way as the front – for example, if the face of the block becomes wet, you should also wet the back, and so on; this 'like' treatment prevents warping and cracking.)

Cutting the Block
There is a great deal of unnecessary mystique and craft 'one-upmanship' when it comes to engraving – materials, methods, tools, etc – but you, fortunately, will be unhindered by any preconceived and inflexible ideas. For this

Printing ink is taken up on the roller and then transferred to the printing surface of the block. Prepared paper is carefully positioned, a piece of thin card is placed over the paper to shield it against too much pressure and then the card is burnished with the back of a metal spoon

project I would advocate the use of the simple lozenge-shaped graver; practice with this single tool will put you on a sound craft footing. As you can see from the illustration in the previous project, the wood is supported on the sand bag with the left hand, while the graver is worked with the right hand (see page 132). In working, the block is supported and manipulated so that in cutting curves, it is the block that is turned rather than the tool. The pressure applied to the tool at any single moment decides the width and depth of the cut; if great pressure is applied, the broad face of the tool digs deep and the cut widens. It must be understood that this one tool is capable of an infinite number of expressions: single marks, fine lines, lines that belly, lines that widen and taper, lines that cross-hatch, curling and snaking lines – the variations are endless. When cutting, be positive and direct, don't fuss and scratch about; make the cut, consider the effect and then move on to another. As all craft processes are a matter of practice and continuous experimentation, don't give up or panic if your first efforts are a mess – try again.

Printing Materials
As there are many different rollers, inks and papers and a great number of working methods, I have made specific selections for you to use as a starting point.
Inks Printing inks come in tins, tubs and tubes and in many colours and consistencies; for this project a small tube of stiff black would be ideal.
Rollers The ink can be applied to the face of the block with a leather dabber, a rubber squeegee or a composition roller, but I suggest that you use one of the rubber or plastic rollers – they are cheap, readily available, easy to use and hard wearing.
Burnishing For small editions I think it is far more instructive and practical if the print is taken with a burnishing tool rather than a massive press. The dish of a dessertspoon or an old toothbrush handle works very well, and a tool of this character has the advantage that the user is in direct contact with the paper and block and so is more able to assess the results.
Paper As in the project on block printing, I suggest using a long-fibred Japanese paper; a material of this type is strong, durable, attractive, fine textured and expressive. However, as this print is specifically for a Christmas card, the fine tissue must be mounted on a good quality cartridge paper after printing.
Printing A small amount of ink is squeezed from the tube on to a sheet of plate glass and then worked and rolled with the roller until it forms a fine film. The ink should be even and firm in texture – it should not be so thin that it

141

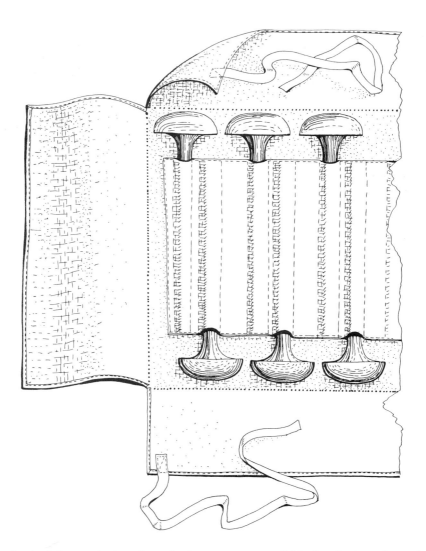

Wood engraving tools have to be kept dry and safe. If they are allowed to rust or clink together, the cutting edges will get damaged

runs or so thick that it clots. Once the ink has been worked, it is taken up on the roller and passed several times backwards and forwards across the block. With great care and in a single, deft and positive movement, the paper to be printed is placed on the inked block; obviously, if the paper is dragged about the print will be ruined. Next, a piece of fine card is placed on the printing paper and then the card is burnished with the back of the spoon. This part of the operation is rather tricky because if you apply too little pressure the ink won't print evenly; experience will guide you. Once the inked impression can be seen through the paper, the print can be lifted by a single corner and peeled off.

Hints and Tips
There are any number of things that can go wrong – the ink might be too thin, the roller might be damaged, the printing paper might be

*Photographically produced metal-plate prints from
Charles O'Connor's woodblock originals*

Design for a print, 'Young Girl'. There has to be a balance between the area that is to be cut away and the block that is to print

Design for a print. The limited-edition information can become part of the total design, and the amount of wood that is cut away is limited to just a few tapering strokes

2–100 RESTING J Bridgewater 1982

too absorbent, the block might warp or split – just observe the results and if necessary readjust the materials and the method.

Limited Print Editions

Taken literally, a limited print edition is one which is limited in that only a certain number of prints are made. Early printers and publishers saw print making as a relatively uncomplicated commercial undertaking – an artist designed the work, a craftsman cut and gouged the wood, a printer took impressions from the block, and finally the prints were sold to the public. As the blocks or plates were kept by the publisher, further impressions were taken as long as there was a market. From the very beginning, it was customary for the artist and perhaps the printer or publisher to sign the work. The rarity value of any single print now relates primarily to two factors: the number of impressions originally pulled and the number that have survived the ravages of time. Obviously the older the print the greater the chance that only a few have survived; also when prints became collectable it was obvious that the commercial value of a print was determined by its rarity.

As far as modern prints are concerned, it has become the accepted practice to limit the number of prints taken from any single block artificially. The artist agrees on the number, and when they have been taken the block is defaced or destroyed. As some artists have been tempted to put the blocks to one side rather than destroy them, it has become necessary for the damage to be seen to be done – the block faces are scratched and then impressions are taken from the damaged blocks.

The actual procedure is as follows. An agreed number of prints are taken, let us say 100; this is the limited edition. Then about 10 per cent are taken and kept by the artist; these are called artist's proofs. Finally, some prints are taken from the damaged blocks; these are called cancellation prints. When a limited edition is published, again say an edition of 100, it is numbered so that the prints read 1/100, 2/100, 3/100, etc; each print is also signed by the artist and then dated. One can usually expect to find these marks at the bottom of the print – the number and date in the bottom right-hand corner, and the title and signature in the centre of the bottom margin, but there are of course always exceptions. The only problem with this method of marking is that the margins might become damaged. Many printers, especially those in the East, actually work the marks or signatures so that they become an integral part of the design.

GLOSSARY

Baren Originally a baren was a Japanese oval-shaped pad, made from a coil of cord covered with a sheath of bamboo leaf. In use it is held in the hand and used to burnish the back of the paper on the printing block. Barens are now made from plastic and wood.

Bible or India Paper Thin, strong paper used in printing and book construction.

Bleed When colours run into each other, or spread out of control, 'the edges of the print have bled'.

Block Book A book in which each page of text and illustration has been cut from a single block. Usually refers to the earliest books that contain text and illustration – German, fifteenth century.

Block Print A print made from the cut plank surface of a piece of wood; the uncut relief surface prints positive – *see* Woodcut.

Bone A smooth bone, wood or plastic spatula that can be used to burnish the back of prints.

Box A uniformly grained wood; used for wood engravings and worked on the end grain.

Brayer A hand roller – made of wood, rubber, plastic, gelatin, etc – which is used to lay ink and colour on to printing blocks and also to apply pressure in the printing process. (*See also* Gelatin Roller or Brayer.)

Buckling When a paper or card bulges and waves; it is caused by uneven and patchy stretching and shrinkage.

Burnisher A smooth rounded tool used in printing – a Western version of the baren, usually made of bone, brass, etc.

Cartridge Paper The English name for the average grade of white drawing paper. It can be bought in several thicknesses and textures.

Cherrywood Cherrywood is the straight, even, close-grained wood used by Japanese block cutters. The best woods are those which are slow growing – Japanese and English.

Chiaroscuro A woodcut technique where each of the tones is printed with a separate block – a key block prints the black, and successive blocks print lighter tones. The finished effect is similar to water-colour and wash painting – sixteenth-century woodcut technique.

Colour Print A Japanese block print. First a black key block is cut and printed, and then successive colour blocks which relate are cut and overprinted. The final effect is clean, bold and highly stylised. Prints of this character are usually printed on a mulberry paper or a strong tissue paper.

Copying or Hand Press A heavy cast-iron screw-operated press – a large 'steering wheel' or bar is turned and a plate and bed are brought together. A press of this type is now used primarily as a proof-taker.

Dabber Another name for a baren – usually a leather-covered pad. In use it is rubbed across the back of the paper that is to be printed. Dabbers are also used to spread printing and grounding mediums.

Design The arrangement and organisation of the colour and textural elements; a description of the craftsman's final solution.

Dry Colour A powdered colour pigment which has been mixed with as little water as possible – the medium used in stencil printing.

Dyes Dyes come in many colours, types and compositions. When using a brand-name dye or printing pigment, always follow the instructions to the letter.

Engraving Cutting into the end grain of certain woods and printing with the resultant relief surface; the relief surface that remains uncut prints black, but it is the white that reads as positive.

Faded Colours A technique where the base medium contains less and less colour pigment, so the end result is one of dense colour fading to non-colour.

Finish Used to describe either the final surface texture – smooth, clear, rough, etc – or a piece of work that is well designed – 'it has finish'.

Flocking To flock a woodblock is to coat it with a fine layer of dye-absorbent fluff. Flocked wallpaper is paper that has been printed with a glue and then passed through a flocking box. The result is a paper that imitates velvet.

Gelatin Roller or Brayer A flexible roller made of gelatin, which is used when sensitivity is required – for example, when putting even layers of colour on a woodblock.

Grain The cell structure of a tree is described as the grain, and the direction of the grain is vertical, as is the growth of the tree. A cut section across the tree growth reveals end

grain. Woodcuts use wood on plank grain, and engravings use the end grain.

Graver or Burin The common name given to tools used in wood engraving. Tools that perform a specific task are named accordingly – multiple point, flat, etc.

Ground The area that surrounds the relief, positive printing face of the block. The printing surface is left in relief, and the non-printing ground is cut away and lowered.

Gum A petroleum mixture that is used to stick paper to paper. It is an efficient joining medium which doesn't expand and buckle the paper.

Gum Arabic This is used to stick material to the table prior to printing, and it is sometimes mixed with dyes to give body. The gum arabic granules are soaked in cold water, boiled for several hours, cooled and then strained. Refer to dye-makers' instructions.

Indian Ink A dense black drawing ink used in illustration and design work.

In situ Work done on site – for example, a screen that has been built and then painted.

Key A key block is the first block in a colour print and the one to which all the following blocks relate. Key marks or windows are marks or holes which are used when matching or aligning subsequent prints to the first – *see* Register.

Lino Cut A method of printing identical to woodcut. Linoleum is used instead of wood; it is easy to work, even in texture and relatively cheap.

Master Design Once the design has been worked out in rough, it is then finalised and worked until it is as near perfection as is possible; this is the master design.

Medieval Character Used to describe work relating to that done in Europe between 500 AD and the fourteenth century. The term medieval refers to a style or manner of working rather than a precise period.

Medium The body which supports the colour or dye. In Japanese block printing the medium is the flour paste which holds the coloured pigment.

Motif A repeated bold form or pattern; the main element of the design.

Natural Dye A dye or colour that is obtained directly from animal or plant material, as opposed to one that is obtained chemically.

Newsprint A cheap wood-pulp paper which can be used for rough experimental work.

Oilstone A slab of artificial or natural stone on which knives or cutting edges are sharpened. In use a small amount of oil is smeared or dribbled on the stone, and the blade or edge is rubbed backwards and forwards.

Original Print A print which has been con-ceived, cut and worked by an artist; the print is usually dated or identified as first edition, or whatever, and also signed.

Parting Tools In woodcuts the parting tool is sometimes used to cut in the main lines of the motif prior to cutting away and lowering the ground.

Proof (also artist's proof) A printed impression made in order to criticise the block. By taking a series of proofs and then correcting the block, a work can be perfected.

Register The term used for the method of print alignment. So that the first key print and subsequent prints are co-ordinated they all have to relate to a registration mark. These take the form of nicks in the printing block surface, holes or key windows in stencil plates, and battens on the edge of blocks.

Relief print Both wood engraving and wood-cuts are relief printing methods; they both take ink from the uncut surface area of the block.

Repeat Glass Four lenses set in a frame; if a design is viewed through such a frame, it is seen repeated several times. A repeat glass would be used by a designer trying to visualise the finished pattern.

Reverse Image or Mirror Image A print taken from a block shows the cut image in reverse; obviously this has to be taken into consideration when cutting and printing letters or cutting a scene where accuracy of left and right handedness is important.

Roller *See* Brayer.

Rubber Cement *See* Gum.

Section A cross-section through a tree trunk would show a series of rings; a section horizontally through a cone would show a circle; a sectional drawing is one that shows a structural dimension.

Slip Carborundum or stone piece for sharpening cutting tools.

Spitstickers Small tools used in wood engraving for fine, curved line work, though they can also be used for straight lines.

Spray Gun A piece of equipment used to spray fine mists. In stencil work dye can be applied with a spray gun – the effect is an even, fine, cloud-like texture.

Steaming (to fix dye) The material that has been printed is allowed to dry; it is then placed loosely between two sheets of old cotton sheeting and rolled into a bundle. This bundle is then placed on a grid in a steamer, boiler or large saucepan, and then steamed according to the dye-maker's instructions.

Stencilling A method of printing in which holes are cut in a thin plate and colour is sprayed or brushed through the holes. If a circle is cut in a stencil plate, it will print as a solid positive circle.

Tint Tool Used in wood engraving to cut the fine lines of the cross-hatching; a fine line tool.

Tracing Paper A thin transparent paper used for copying. The tracing paper is placed over the master drawing, and the lines are pencilled in. The tracing can then be mounted directly or pencil pressed on to the block or stencil.

Varnish A plastic or resin solution that dries as a hard transparent film; it can be used as a protective coat or as a waterproofer.

Vinyl A thin smooth plastic sheet which can be used for stencil cuts and relief printing.

Woodcut A relief printing method that uses the plank surface of the wood. The design is drawn on the wood and the ground or non-printing wood is then cut away, leaving the area that is to be printed in high relief.

Wood Engraving *See* Engraving.

Wrinkle or Buckle When a card, paper or print is damp the material expands unevenly and ripples.

BIBLIOGRAPHY

Beal, George *Playing Cards and Their Story* David and Charles, 1975.

Biggs, John R. *The Craft of Woodcuts* Blandford, London, 1963.

Braby, Dorothea 'A Way of Wood Engraving' *The Studio*, 1953.

Brommer, G. F. *Relief Printing* Ward Lock, 1970.

Burgess, Fred W. *Old Prints and Engravings* Tudor, New York, 1947.

Butlin, Martin *William Blake* Tate Gallery, 1978.

Chamberlain, Walter *Wood Engraving* Thames and Hudson, 1978.

Clark, Fiona *William Morris's Wallpapers and Chintzes* St Martin, 1973.

Davis, Alec *The Graphic Work of Eric Frazer* Uffculme, 1974.

Dobson, Margaret *Block Cutting and Print Making By Hand* Pitman.

Earle, Joe *An Introduction To Japanese Prints* Victoria and Albert Museum, London, 1980.

Entwistle, E. A. *The Book of Wallpaper* Kingsmead reprints, 1970.

Fletcher, F. M. *Woodblock Printing* Pitman.

Jackson, John *A Treatise on Wood Engraving* Charles Knight, 1839.

Kurth, W. *The Complete Woodcuts of Albrecht Dürer* Dover, 1963.

Mackley, G. E. *Wood Engraving* National Magazine Company, 1948.

Marqusee, M. *Images from the Old Testament* Paddington Press, 1976.

Mayer, R. *A Dictionary of Art Terms* Adam and Charles Black, 1969.

Naylor, G. *The Arts and Crafts Movement* Studio Vista, 1971.

O'Connor, J. *The Technique of Wood Engraving* Batsford, 1971.

Panofsky, E. *The Life and Art of Albrecht Dürer* Princeton, 1955.

Reade, Brian *Aubrey Beardsley* Studio Vista, 1969.

Robinson, S. and P. *Exploring Fabric Printing* Mills and Boon, 1970.

Seiichiro, T. and I. *The Traditional Wood Block Prints of Japan* Weatherhill, Heibonsha, Tokyo, 1972.

Steven, R. *A Complete Guide to Printmaking* Pelham/Nelson, 1975.

Stone, R. *Wood Engravings of Thomas Bewick* Rupert Hart Davis, 1953.

Strauss, W. L. *Chiaroscuro* Thames and Hudson, 1973.

Taylor, A. C. *English Parish Churches As Works of Art* Batsford 1974.

Thompson, D. C. *The Life & Works of Bewick* 1882.

Tuer, A. W. *Japanese Stencil Designs* Dover, 1967.

Victoria and Albert Museum *The Engraved Work of Eric Gill* London, 1977.

Waring, J. *Early American Stencils on Walls and Furniture* Dover, 1968.

Watkinson, R. *Pre-Raphaelite Art and Design* Studio Vista, 1970.

Wilder, F. L. *How to Identify Old Prints* Bell and Son, 1969.

Old Magazines

Leisure Hour 56, Paternoster Row, London, 1876.

The Girls Own Paper London, 1855.

The Art Craftsman vol 1 (Oct 1908–Sept 1909) London, 1909.

SUPPLIERS

Dye Stuffs and Related Products

Arnold Hoffman and Co Inc
55 Canal Street
Providence
Rhode Island
USA

Candle Makers Suppliers
101 Moore Park Road
London SW6

Dryad Handicrafts
Northgate
Leicester

Geigy Chemical Co
PO Box 430
Yonkers
New York
USA

Griffin and George Ltd
PO Box 13
Wembley
Middlesex

Margros
Monument House
Monument Way
West Woking
Surrey

Mayborn Products Ltd
Dylon Works
Sydenham
London SE26

Pronk Davis and Rusby Ltd
44 Penton St
London N1

Inks

American Handicrafts Co Ltd
20 West 14th Street
New York
USA

Coates Bros Inks Ltd
Grape Street
Leeds LS10 1DN

L. Cornellison
22 Great Queen Street
London WC2

Dryad Handicrafts
Northgate
Leicester

F. Horsell and Co Ltd
Victoria Road
Leeds

Papers

Andrews, Nelson and Whitehead
7 Laight Street
New York
USA

Falkiner Fine Papers Ltd
4 March Street
Covent Garden
London WC2

T. N. Lawrence and Sons Ltd
2 Bleeding Heart Yard
Greville St
Hatton Grd
London EC1

Japan Paper Co
100 East 31st St
New York
USA

Silks and Other Fabrics

American Handicrafts Co Inc
20 West 14th Street
New York
USA

Emil Adler
46 Mortimer St
London W1

Dryad Handicrafts
Northgate
Leicester

Fabric Distributing Co
551 Eighth Ave
New York
USA

Woods and Tools

Craft Tool Co
Industrial Rd
Woodridge
New Jersey 07075
USA

Dryad Handicrafts
Northgate
Leicester

T. N. Lawrence and Son Ltd
2 Bleeding Heart Yard
Greville St
Hatton Grd
London EC1

Sander Wood Engraving Co Inc
212 Lincoln St
Porter
IND 46304
USA

E. C. Young
PO Box 118
Carpenters Rd
Stratford
London E15 2DY

ACKNOWLEDGEMENTS

Gill and I both wish to thank the following: Chrystie O'Connor of Pinfold Studio, Girton, near Newark, Notts, for her kind permission to reproduce Charles O'Connor's work; Roy Stephenson, the printer at the Millgate Museum of Folk Life, Newark on Trent; John Bridgewater for his help with photographs; Peter Bridgewater for his general help; John Grain for his help with prints; Zul for his help with photographs; and Mr and Mrs L. G. Hill, Glyn and Julian for their constant help during a very difficult 'between moves' time.

INDEX